Expressionism

Phaidon 20th-century Art

With 80 colour plates by the following Artists

Derain	Nolde	Feininger
Ensor	Pechstein	Hofer
Gauguin	Schmidt-Rottluff	Kokoschka
Munch	Campendonk	Kubin
van Dongen	Jawlensky	Meidner
van Gogh	Kandinsky	Modersohn-Becker
Vlaminck	Klee	Rohlfs
Heckel	Macke	Beckmann
Kirchner	Marc	Dix
Otto Mueller	Münter	Grosz

Maly and Dietfried Gerhardus

Expressionism

From artistic commitment to the beginning of a new era

Phaidon · Oxford

The author and publishers wish to thank the various museums and galleries for their help in the production of this volume. Ludwig Meidner's *Self-portrait* is published for the first time by permission of the Saarland Museum, Neue Galerie.

Translated by Stephen Crawshaw

Phaidon Press Limited, Littlegate House, St Ebbe's Street, Oxford
First published in Great Britain 1979
Published in the United States of America by E. P. Dutton, New York
Originally published as *Expressionismus*
© 1976 by Smeets Offset BV, Weert, The Netherlands
German text © 1976 by Verlag Herder KG, Freiburg im Breisgau
English translation © 1979 by Phaidon Press Limited
Illustrations © Beeldrecht, Amsterdam

ISBN 0 7148 1951 4
Library of Congress Catalogue Card Number: 78-74422

Printed in The Netherlands by Smeets Offset BV, Weert

Contents

Colour plates with short interpretations

Front cover:

Max Beckmann
Self-portrait with Blue Jacket, **1950**
Oil on canvas, 140 × 91 cm
St. Louis, Mr. and Mrs. M. D. May

Ernst Ludwig Kirchner
Self-portrait with Model, **1910**
Oil on canvas, 150.4 × 100 cm
Hamburg, Kunsthalle

Back cover:

André Derain
Dancers, *c.* **1906/7**
Oil on canvas, 49 × 44 cm
Paris, R. Lebel Collection

Paul Klee
Villa R, **1919**
Oil on cardboard, 26.5 × 22 cm
Basle, Kunstmuseum

'We were possessed. In cafés, on the streets, in the squares and in studios, day and night, we were "on the march", driving ourselves on at a mad pace, to fathom the unfathomable, and, united as poets, painters, and musicians, to create the "art of the century", incomparable, surpassing all the arts of all the preceding centuries.'

Johannes R. Becher

'It was a burdened generation: derided, scorned, politically rejected as degenerate — a generation abruptly, out of the blue, shatteringly struck down by accidents and wars, destined for a short life.'

Gottfried Benn

Anti-academic attitudes in Romanticism and Expressionism

'Subjective art', 'mere mood-painting', 'composition stemming from the individual imagination', 'subjective expression of feeling' — these are some of the phrases used to describe Romantic painting, whose surprising popularity was revealed by the large exhibition of the work of Caspar David Friedrich (1774–1840) in the Hamburg in 1974. But conventionally-used words like 'subjectivity', 'emotion', 'individuality', and so on, become virtually meaningless slogans when applied to Expressionism, the programmatic art movement of the beginning of this century.

There are some notable parallels between Romanticism and Expressionism in terms of artistic commitment. The desire for both artistic and social renewal of life was common to both movements. The Romantic artists attacked the empty routine of what Philip Otto Runge (1777–1810) called the academic 'ghettos', and the 'infirmary' art schools, as Schiller described them. Caspar David Friedrich was of the opinion that the art academies turned the artist into a 'machine'.

What was it that this anti-academicism attacked, and what consequences did it have for art as a whole?

Whereas in the sixteenth century, genius was created and sustained by the academies, the Romantic genius was born amongst the opponents of the academic style. This 'original genius', as depicted by Wilhelm Heinse in his artist's novel (the first of its kind) *Ardinghello, or the Fortunate Islands* (1787), was against both the art school as a public institution and the public which was primarily accustomed to academic art. Thus the Romantic artist no longer wanted to be bound by imposed rules, and was determined to allow his own artistic imagination to achieve total self-expression. This 'subjectivity' thus meant that the individual artist no longer accepted the academic canon. Instead, he attempted to work according to rules which had not been decreed by institutions—rules, in other words, which he found for himself, and which affected his artistic

approach, his style, and his choice of subject matter. Part of the academic canon of traditional painting was for instance, that the picture should be composed of basic geometrical figures—circles, ellipses, triangles, and so on. The subject matter was also predominantly drawn from Greek mythology and Christian tradition.

For the anti-academic painter of the Romantic period, there was no such restriction on subject matter. He was no longer subject to any outside norms, and thus also no longer felt tied to prescribed ways of looking at objects in the visible world. He established other, individual ways of looking at things, organized the picture in his own way, and devised his own pictorial language—which, of course, became in turn normative, as can clearly be seen in Runge's work. This subjective artistic approach meant that the artist's own relation to the depicted objects was particularly emphasized. He worked on the basis of the patterns of experience that he had developed in his personal relation to the world.

The connections with the art schools, which had been radically severed, were replaced by stronger connections between the artists themselves, and it was this that led to the artists' friendships and the foundation of artists' associations during the Romantic period. These connections, based not only on an artist's style, but also on his whole creed and philosophy, formed the counterbalance to the academic institutions, and were simultaneously directed against the establishment as a whole. An attempt was made to share not only artistic aims, but also an appropriate new way of life, e.g. of a religious or ascetic character.

The artists' anti-academic attitudes, typical of the early nineteenth and early twentieth centuries, were in addition marked by the constant growth of the artists' own commentary on their work and ideas. Previously, the academies had been responsible for providing the intellectual and philosophical framework for artistic activity, which the pupils had taken for granted. Now, however, the artist gradually began to reflect and construct new norms for himself on the basis of his own artistic practice, and it is this practical basis that gives such theoretical reflections their special character.

These observations, derived from the artists' own artistic practice, and forming the basis for their insight into past and present art, were neither a substitute for aesthetics nor any kind of prescriptive method; rather, they are essentially reflections on the production of works of art, and on the visual problems posed by artistic activity and its aims, and are thus an ideal key towards the understanding of these works. Their value lies in the clues that they give us to an artist's intentions.

For the end of the nineteenth and the beginning of the twentieth centuries, anti-academicism was the slogan which dominated the international art scene: the *secessio plebis* with which the inhabitants of ancient Rome had asserted their rights served as a kind of model for artists around the turn of the century. Like the Nazarenes in the Romantic period, founded by Johann Friedrich Overbeck (1789–1869) and Franz Pforr (1788–1812) in Vienna in 1809, the artists at the end of the nineteenth and the beginning of the twentieth centuries withdrew protesting from the old art schools and artists' societies, and founded their own open artists' associations with new aims. These new associations had a significance beyond that of the individual groups, and led to an international exchange of artistic ideas. The Munich Secession was founded in 1892, the Vienna Secession in 1897, and the Berlin Secession in 1898. Their exhibitions bore witness to a new artistic philosophy. Slavish imitation and the academicism of the 1870s were gone for good. The glib representational art of the Wilhelminian era was attacked. The Impressionists' use of light and colour was admired, though artists were wary of the danger intrinsic to Impressionism, i.e. superficialization through dependence solely on impressions.

The artists were interested in the production and the effect of their pictures, and also in understanding the nature of their social responsibilities. The explorations of, for instance, the Expressionist 'Brücke' group in Dresden were not confined to short-lived programmes and manifestos. The Russian Wassily Kandinsky, co-founder of the second Expressionist group in Germany, 'Der Blaue Reiter' ('The Blue Rider') in Munich, discussed visual problems, beginning with his application of the simplest artistic techniques; twentieth-century art theory has been decisively influenced by his essay *Punkt und Linie zur Fläche* ('Point and Line to Plane'), published in 1926, where he formulated for the first time his concept of a syntax of visual signs no longer tied to objective ways of seeing things.

The Romantics accepted no restrictions on their subject matter; Kandinsky in 1910 began to depict what previously had not even seriously been considered as a subject at all: instead of painting houses, trees, animals, and people, he simply created clusters of lines and juxtaposed coloured shapes within a plane, and 'improvised' with artistic techniques—in other words, he painted 'non-objective', 'abstract' or 'concrete' pictures. We may talk of 'non-objective' painting in the sense that no objects of the visible (natural, cultural, or social) world are depicted. The word 'abstract' is used to indicate that this style attempts to be without reference to the visible world. The word 'concrete', on the other hand, emphasizes the subject matter, and the fact that self-contained and self-sufficient images, forming their own context, are created by the artist.

Critics, including Goethe, had already during the early Romantic period commented that some paintings of the Romantics bore such a tenuous relation to any tangible object that they could just as easily be 'looked at upside down'.

The new role of colour and the Symbolist change of subject

Words used to describe and distinguish the different directions, styles, and characteristic features of artistic movements have always caused difficulties both for critics and for art historians, not least because such distinctions and characterizations, particularly in modern art, are often made arbitrarily, on the basis of only a few examples of a genre, rather as a boy gets a nickname because of some distinguishing feature—red hair, for instance—or typical behaviour, after which the nickname takes root and gradually usurps the child's actual name. Thus the critics, after seeing Claude Monet's *Impression—soleil levant*, exhibited in Paris in 1874, then used the term 'Impressionism' to describe everything that was new about this kind of painting. It was the same with nearly all the various 'isms' of modern art—Fauvism, Expressionism, Futurism, Cubism, and so on—which were often comparatively accidental descriptions, but then, like a nickname, stuck, as the name to describe particular stylistic traits.

This is especially true of the art at the beginning of this century, which generally goes under the name of 'Expressionism'. The term was in fact historically remarkably vague: in the catalogue to the exhibition at the Salon des Indépendants in Paris in 1901, where exhibitors included Albert Marquet (1875–1947) and Henri Matisse (1869–1954), the word *expressionisme* was used with reference to some naturalist studies by Julien-Auguste Hervé—but the word did not find general currency in France to describe a particular conception or art. It was not until after the twenty-second Berlin Secession exhibition in 1911, under its new chairman Lovis Corinth (1858–1925), who had replaced

Max Lieberman (1847–1935), where works by Georges Braque (1882–1963), André Derain, Emile Othon Friesz (1879–1949), Pablo Picasso (1881–1973), Raoul Dufy (1877–1953), and Albert Marquet were labelled together as 'Expressionists', that the word 'Expressionism' became common as a stylistic description for young German artists, too, so that art historians like Wilhelm Worringer, for example, began to use the word predominantly in this sense. It should also be pointed out that although painters were often called Expressionists on the basis of their work, they rarely used the word of themselves. Later, the word was also applied to poetry, and the classic Expressionist anthology, *Menschheitsdämmerung—Symphonie jüngster Dichtung* ('Twilight of Man—Symphony of Newest Poetry'), was published by Kurt Pinthus in 1919.[1]

As the origins of the term indicate, Expressionism at first represented everything within the European avant-garde that could not be classified as Impressionism. Later, after the very brief period of German painting in this style—publications with titles like *Post-Expressionism* and *The Overcoming of Expressionism* appeared in 1925 and 1927 respectively[2]—the word Expressionism was reserved almost exclusively for German art, essentially running parallel to the development of Cubism in France and of Futurism in Italy. First, however, let us look at Fauvism as a precursor of Expressionism.

After their joint exhibition at the Salon d'Automne in 1905, the word 'fauves' ('wild beasts', or 'savages') was used as a kind of nickname for the loosely-knit group of young artists which had formed around Matisse in Paris between 1898 and 1905. These artists, now often regarded as 'Pre-Expressionists', included, apart from Matisse himself, Derain (Ills. 1, 2), Maurice Vlaminck (Ills. 16, 17), and Kees van Dongen (Ills. 11, 12). They had no developed programme, but were united by the difficulties (which lasted until their years of success between 1905 and 1907) which they experienced in trying to make their artistic ideas gain acceptance with the public. All the artistic styles of the second half of the nineteenth century were concerned with various aspects of the problem of how to depict different effects of light and atmosphere. After the experiments in *plein-air* painting—by Johan Jongkind (1819–91), for instance—and the Impressionists' interest in colour theory, came the dabbed application typical of Virgulism and Neo-Impressionism or Divisionism, combining the colours of the spectrum, dot by dot, into two-dimensional objects; the exploration of the problem finally culminated in the endeavours of the Fauves, who sought to heighten the expressive value of colour by freeing it from its dependence on a specific object, so that, as one of the Fauves, Emile Othon Friesz, wrote, it becomes transformed into 'pure colour', and its 'starting point is . . . feeling towards nature'. The liberation of colour from its 'subordinate' function gradually made it an independent element of the composition, as in Derain's *Coastal Landscape* (Ill. 2), or Vlaminck's *Sailing Boat* (Ill. 16).

In attempting to treat the colours within the picture as an independent element, the artist was faced with the fact that colours, no longer simply intended to give colour to objects, still inevitably, through their very existence as colours, took up greater or lesser areas of the canvas; they appeared as colour masses, or colour forms. Inasmuch as the representation of objects (mountains, trees, etc.) is intended, colour and object forms clash, with the result that independent colour forms gradually begin to overlap with and then to displace the object forms.

The Fauves were especially inspired by the late works of Vincent van Gogh (Ills. 13, 14, 15), with their coarse and varied brushstroke, and the lack of colour blending or shading. The decorative tendency of Paul Gauguin's pictures (Ills. 5, 6), also had a considerable influence.

The Nabis group (*Nabis* is the Hebrew word for 'prophet') was formed after Gauguin's meeting with Paul Sérusier (1863–1927) in 1888, and included, apart from them, Pierre Bonnard (1867–1947), Félix Vallotton (1865–1925), and Edouard Vuillard (1868–1940), with Maurice Denis (1870–1943) as their theoretician. Gauguin and other artists in the group developed colour forms as two-dimensional forms which overlapped with the pictorial objects to be distinguished. Forms independent of objects thus existed side by side with the objective composition, and then became more and more dominant. The conventions of central perspective were thus abandoned, as was colour perspective (pure, warm colours now occurred in the middle ground and background of the picture as well), thus emphasizing the two-dimensional quality of the composition.

This approach was supported by, for instance, the raising or the deliberate exaggeration of the horizon (cf. Ills. 1, 6). This pictorial organization for the first time achieved the aim of not presenting the observer with, say, a red coat, or red tiles, or the glittering air, but simply with 'red', or the qualities of red, encouraging him to relate directly to the colour. The objective fragment of the world was only represented to the extent that it was necessary for the composition and for the interplay of colour forms, and that it was able, for instance, to give visual strength to the picture. At the same time, graphic conventions of objective representation, used to provide the linear framework of the picture, were largely retained.

The treatment of colour as a theme in itself was accompanied by a change in attitude towards what was considered worth portraying. Instead of taking objects surrounding us in the visible world, natural processes and different aspects of human behaviour were now preferred. Since there were no longer any unambiguously tangible visual objects, this change of subject also meant a move away from the conventions of the portrayal of the objective, familiar through daily contact with the visible world, and through the Western tradition of painting. Two examples will serve to illustrate this point.

James Ensor was born in Ostend in 1860, and died there in 1949, without ever having left his home town except for one brief visit to Brussels. He was deeply influenced by Turner's light painting, and spoke of him having been one of the first to make possible a 'liberation of vision'. His mask pictures were clearly determined by his ideas on composition. They allowed him to deviate from the academic norm of the representation of visible objects, and to develop his own pictorial language. On the occasion of the exhibition of his works at the Jeu de Paume in Paris in June 1932, he declared that 'the mask for me signifies freshness of tone, exaggerated expression, grand setting, broad unexpected gestures, unrestrained movements, exquisite turbulence. . .'.[3] Ensor achieved the powerfully expressive quality of these works not by portraying man directly, but by the use of masks as a pictorial context, designed to arouse shock, disgust, and fear in the beholder.

The Norwegian Edvard Munch, who in particular revolutionized graphic techniques, worked in Paris in 1889, and there got to know the works of van Gogh and Gauguin. In 1892 an exhibition of his most important early works in Berlin caused a scandal; it was on this occasion that young painters split off from the Verein der Berliner Künstler ('Society of Berlin Artists'), which was responsible for the exhibition, and began to organize their own shows, the starting point for the Berlin Secession, founded under Liebermann in 1898. At the important Sonderbund ('Special League') exhibition in Cologne in 1912, Munch was reckoned to be one of the most important pioneers of modern art, together with Paul Cézanne (1839–1906), van Gogh, and Gauguin. Thirty-two of his works were shown at this exhibition, where a whole room was devoted to his work. Eighty-two of his paintings were confiscated by the Nazis in 1937 as 'degenerate', and sold privately. abroad. The lack of

appreciation of Munch's painting is balanced by the fascination which his work exerts. With uncompromising directness he expressed the essential dichotomy in man as both a natural and a cultural being. He wanted to create a complete frieze of life with his art. His themes are the pivotal points between man's naturalness and cultural dependence: youth, love, conception, fertility; approach and separation, illness, old age, death, and transience.

For these themes he developed a radically new graphic approach, which has considerably influenced much twentieth-century work. He succeeded in portraying man as a natural being, and in intertwining the culturally dependent and the natural figure with one another. He depicted man's created environment—e.g. interiors—as though this created environment was itself a kind of nature, 'man's inner landscape', as it were. His portrayals of people often reveal a duality: man as human being, and at the same time man as a natural form. The painter achieves this effect by his constant doubling of line and brushstroke, where he seems to paint with line and draw with colour. In *The Scream* (Ill. 8), for instance, the treatment of line and colour is such that we are presented with the individual character not of a screaming person, but of the scream itself.

It should be borne in mind that this change in subject matter does not indicate an artistic preoccupation with man as a whole—the artist is concerned with those unfathomable behavioural qualities which are peculiar to man, and, in particular, with those kinds of behaviour which are expressed when man finds himself in extreme situations, and which supersede conventional protrayals, nudes in academic poses, and so on, as subjects. Characteristic of these new themes is the fact that the individual features of the picture tend to have several possible interpretations. The organization of the picture, with its mixture of discrete elements, and with the mere suggestion or disproportionate enlargement of details, allows the observer to interpret the picture in his own way, and is one of the most characteristic features of European Symbolism.

Internationalism of the art scene as a condition for the growth of Expressionism

The Expressionist movement was 'destined for a short life', as Gottfried Benn wrote, and its artistic achievements were all essentially concentrated into a single decade, between about 1905 and the First World War. Several of the most important Expressionists, including Franz Marc and August Macke, were killed in the war. It should also be borne in mind that we are here primarily dealing with Expressionism as an early twentieth-century stylistic phenomenon, rather than with the life work of individual artists (though the plates do in fact deliberately include representative later works by these artists).

In 1905 the Fauves held a successful exhibition at the Salon d'Automne in Paris, and were from then on considered as a group. In the same year Erich Heckel, Ernst Ludwig Kirchner, Karl Schmidt (who later changed his name, after his native town, to Schmidt-Rottluff), and Fritz Bleyl founded the 'Brücke' group in Dresden, the first important artists' community in Germany in the twentieth century. Munich was at that time the most important German centre of the arts after Berlin (Kandinsky, Marc, and Gabriele Münter founded 'Der Blaue Reiter' there in 1912), and several artists gravitated from there to Paris, the European artistic metropolis: Kandinsky and his companion Gabriele Münter spent six months in Sèvres and Paris, where Kandinsky, who had already been there between 1889 and 1891 at the same time as Munch, became a member of the Salon d'Automne and the Salon des

Indépendants. Kandinsky's compatriot Alexej von Jawlensky, whose journey through Provence and Brittany also took him to Paris, exhibited ten pictures at the Salon d'Automne in 1905. Paul Klee also stayed there for a short time in 1905, as did Alfred Kubin, who there made the acquaintance of Odilon Redon (1840–1916). Visitors to Paris later also of course included Marc and Macke.

Paula Modersohn-Becker lived in Worpswede, where she was a close friend of the sculptress Clara Westhoff (1878–1954), the wife of Rainer Maria Rilke (whose *Stundenbuch* was also published in 1905). During her third trip to Paris, in 1905–6, she studied at the Académie Julian, as did Ludwig Meidner in the following year. Max Pechstein concluded his Italian visit in 1907 (made possible by a grant from the Dresden Academy) with a detour via Paris, where he got to know van Dongen, and invited him to the Brücke exhibitions. The Swiss artist Cuno Amiet (1868–1961), whose work is now thought of as closer to *art nouveau*, like that of the Finn Axel Gallén-Kallela (1865–1931), worked in 1890–91 in Pont Aven and in the Gauguin circle; Gallén-Kallela became a member of the Société Nationale des Beaux-Arts in Paris at the same time. Both artists were members of the Brücke for a brief period in 1906, as was Emil Nolde, who had gone to Paris in 1899.

But Paris was not the only market-place of artistic fashions and ideas. In Germany, too, there was considerable exchange of information. The Arnold Gallery in Dresden, for example, showed works by French Impressionists and Neo-Impressionists in 1902, works by van Gogh in 1905, and pictures by the Neo-Impressionists in 1906, including works by Paul Signac (1863-1935) and Georges Seurat (1859-91), and also by Gauguin and van Gogh. In Munich, works by Camille Corot (1796–1875), Gustave Courbet (1819–77), Jean François Millet (1814–75), Arnold Böcklin (1827–1901), Liebermann, and Corinth could be seen in 1893, and works by Cézanne, Gauguin, and van Gogh were exhibited at the Munich Künstlerverein in 1906. The 'Phalanx' artists' association, which was founded by Kandinsky in 1901, and existed until 1904, organized an exhibition of pictures by Neo-Impressionists in 1904.

The Berlin Keller and Reiner Galleries showed examples of Neo-Impressionist painting in 1898, the Berlin Nationalgalerie bought works by Cézanne in 1900, and the Berlin Secession exhibited Munch in 1902, and works by Pierre Bonnard (1867–1947), Cézanne, and Gauguin in 1903. The Cassirer Gallery (established in 1898) showed Cézanne in 1904, and Cézanne, Matisse, and Munch in 1907.

There was also considerable traffic in the other direction. In 1891, Ferdinand Hodler (1853–1918) was represented in the exhibition in the Champ du Mars in Paris by his famous *Night*. Munch was exhibited in the L'Art Nouveau Gallery (run by the German S. Bing), which was to become the first *art nouveau* gallery in Paris, in 1896; he exhibited again at the Salon des Indépendants in 1897. In 1905, Kandinsky exhibited at the Salon d'Automne and the Exposition Nationale des Beaux-Arts, and Jawlensky, as already mentioned, exhibited at the Salon d'Automne in 1905.

These examples could be multipled. The large number of exhibitions shows the extent to which the new tendencies in art were not bounded by geographical frontiers—there was even an exhibition of French Impressionists in Moscow in 1895. It is genuinely possible to speak of an international art scene at the beginning of the century. Herwarth Walden's *Einblick in die Kunst* ('Insight into Art')[4] tells us that from 1912 his Sturm Gallery put on 150 exhibitions in Berlin alone, and more elsewhere in Germany. Exhibitions from here travelled not only over the whole of Europe, but also to America, and even to Japan.

The attempt to find direct models is thus almost as unproductive as the opposite tendency, to turn the artist into a 'solitary genius'. Nor can the German Expressionists be seen as artists independent of

outside influences and artistic information, as is often claimed, particularly of the Brücke painters.

The Expressionists' consciousness of their debt to the international art scene is indicated by Marc's and Kandinsky's reference in the almanac *Der Blaue Reiter*, published by them in 1912,[5] to 'die Wilden'—the wild beasts, or savages, a literal translation of the French word 'Fauves'—of Germany and Russia. By this they of course meant not only the artists of the Blaue Reiter, but also those of the Brücke in Dresden and later Berlin, and the Berlin Neue Sezession, and, for example, the Russian David Burlyuk (1882–1958).

The word 'Wilde' (or 'Fauve'), at first used pejoratively, had by this time lost its negative connotation, though not its provocative character. Thus one review of the Vienna International Art Exhibition in 1908, where Oskar Kokoschka publicly exhibited some of his works for the first time, declared: 'There is even a "wild cabinet". The chief wild beast [der Oberwildling] is called Kokoschka, and his work promises great things . . .'.[6]

The mass of artistic information at the beginning of the century at the same time serves as an index of the intensity of artistic production. The Expressionist painters were 'on the march', in order to create 'the art of the century'. The catalogue of Kirchner's works lists sixty-two paintings dating from 1910, for example. The Munch Museum in Oslo, opened in 1963, documents around 10,000 examples of his graphic work, comprising around 800 separate items, where the countless different styles of printing and colour variants of the individual items indicate his enormous productivity.

This productivity on the part of the individual artists, combined with widespread exchange of information, meant that qualitative judgements became possible not just at a historical distance, or in retrospect. Contemporaries were equally able to form judgements, on the basis of the range of different works. Thus, for example, in 1911 the Brücke artists separated, after only brief membership, from the Neue Sezession (the New Berlin Secession), which had been founded earlier in the same year, because they regarded the works of many of their fellow-members as mediocre. In the same year, the artists of the Blaue Reiter left the Neue Künstlervereinigung München for the same reason.

The first artistic monograph on Pechstein appeared as early as 1912, on Schmidt-Rottluff in 1918, and on Kirchner, Kandinsky, Heinrich Campendonk, and Klee in 1920. Unlike Expressionist poetry, by 1920 it was fairly clear who the most important Expressionist painters were, and the assessments have remained essentially valid up to the present day. The mass of information and productivity brought with it the now familiar syndrome of a shortlived avant-garde, with new stylistic tendencies following one another in rapid succession. The interested observer quickly learned to know and to accept the novel, and quickly saw much as old-fashioned and conformist. This phenomenon led to a kind of obsession with novelty, so that novelty or lack of it often threatened to become the only criterion for judgement.

Centres of expressionist painting: the Brücke and the Blaue Reiter

Futurism tended to begin with manifestos and programmes and to progress from there to artistic practice. Cubism moved away from an artistic practice primarily dealing with a central problem towards pioneering concepts and revelations, always accompanied by theoretical pronouncements. Expressionism, on the other hand, was a historically much broader movement, short-lived and much less clearly defined, whose very varied artistic work was always practical, and effectively sought to

exist without any theoretical paraphernalia. Although there is an undoubted intrinsic connection between the many 'isms' of the beginning of the twentieth century (ten or a dozen come immediately to mind), it would be a gross over-simplification to see Expressionism, Futurism, and Cubism as mere national variants of an essentially uniform style. It would be difficult to find the common denominator in a mass of different artists and groups, often based on journals, publishing houses, and galleries, and often hostile to one another.

Der Sturm, founded by Herwarth Walden in 1910, was undoubtedly the most important journal of the Expressionist decade—after only a short time, it had a circulation of 30,000, almost inconceivable for a progressive art journal nowadays, and the Sturm Gallery was affiliated to it in 1912. But it would be misleading to see it as the 'central organ of Expressionism' (as P. Pörtner described it). It would be equally mistaken to separate the two Expressionist artist groups, the Brücke and the Blaue Reiter, from the mass of artistic currents, and to look at them in isolation just because they were groups. But in this introduction we must limit ourselves to looking at a few of the main directions, since an approach which attempted to describe all the individual details of the movement would make a satisfactory illustrated documentation impossible, and would effectively destroy the connection between the introduction and the illustrations. Some examples will suffice to indicate how Expressionism managed, at least for a time, to make its goal of shared artistic activity a reality—though this practice should on no account be confused with the theoretical considerations that followed later. The founding document, which barely merits the word 'programme', composed and carved in wood by Kirchner only a year after the foundation of the Brücke, is really no more than a declaration of intent, a kind of common stimulus: 'Believing in development, in a new generation of those who create and those who enjoy, we call together all youth, and, as youth bearing the future, we want to create freedom of art and life against the ensconced older forces. All belong to us: anyone who directly and truthfully reproduces whatever impels him to create.'[7]

This all-embracing desire for common artistic practice, which puts all artistic activity—drawing, painting, lithography, engraving—beyond discussion, is very characteristic of the Dresden Brücke group (their name, invented by Schmidt-Rottluff, literally means 'The Bridge'), and particularly distinguishes them from the Munch Blauer Reiter group.

In this connection, other characteristic features should be noted. Heckel, Kirchner, Schmidt-Rottluff, and Bleyl (all former architecture students) attempted to form not simply a group, designed to pursue common interests in any particular sphere. Rather, they desired to form a community in the fullest sense of the word, simultaneously involving their artistic work and their whole lifestyle. Equally important is the fact that when the group was founded, they were only just beginning as painters and graphic artists. They were also self-taught in this respect—only Kirchner had interrupted his architecture studies for a short time in order to go to the Munich Academy, and he, too, soon resumed his architecture training, and took his final exams in architecture.

Artists who joined the group later, like Nolde, Amiet, van Dongen, or Gallén-Kallela, did not want to become absorbed by this overwhelming sense of community; it was in addition difficult for the community itself to continue in this direction for more than a short time, since the individual development of each artist inevitably became a testing point for the survival of the group.

They often shared studios, and lived surrounded by furniture which they had themselves constructed from crates, for instance, which they had themselves painted. One of the group would carve in wood what another had painted. They used the same stone for lithography. They kept a kind of communal artistic diary, in which each group member, in addition to the ordinary entries, noted down his

creative ideas. In the winter they worked together in Dresden, in the summer they usually worked on the Moritzburg Lakes near the town. They went on study trips together, too. They held joint exhibitions, the first of which was in the Seifert lamp factory in Löbtau near Dresden in 1906. They had a poster competition within the group for this exhibition: Heckel's design was chosen, and the gap between the new ideas in art and the reigning conception of what was portrayable and worth portraying, and, in particular, how certain subjects should be depicted, is illustrated by the fact that Heckel's design, a wood engraving of a female nude, was not permitted by the police to go on public display. Kirchner then designed a more 'neutral' poster—also, incidentally, depicting nudes. The Brücke painters retained their sense of community in subsequent exhibitions, too. Guest artists were occasionally invited, e.g. the Hamburg painter Franz Nölken (1884–1918) in 1907, and van Dongen in 1908. Public success followed quickly, so that in 1907 there was already a touring exhibition which visited Braunschweig, Hamburg, and Leipzig.

In order not to be solely dependent on their own mutual criticsms, and in order to have some kind of outside check—and also, of course, to improve their financial situation—a year after the foundation of the group the Brücke painters started accepting subscribers, who, in return for their contributions, received an annual 'graphics portfolio', and were continuously kept in touch with the activities of the group. The declared intention of the founding programme, to induce 'those who enjoy' to become a part of the activity at the earliest possible stage, was thus realized from the very beginning.

The strong sense of community of the Brücke painters had a very direct consequence for their art: their early works are often stylistically so similar that it is easy to confuse them.

In 1907 Pechstein became a permanent member of the group. He moved to Berlin after his stay in Italy in 1908, and the rest of the Brücke painters followed him there at the end of 1910. Otto Mueller joined the group at the same time. Bleyl had already left the group a year earlier, in order to earn a living in some other way.

The rejection by the jury of the 1910 Berlin Secession of pictures by Pechstein and by twenty-seven other artists, including Nolde's famous *Pentecost*, led to the formation of the Neue Sezession, to which the Brücke artists were attached for a short time. Their participation in the Sonderbund exhibition in Cologne in 1912 may be regarded as their greatest success during their group collaboration. The Berlin period, which enabled the artists to find their individual styles and led to their artistic breakthrough, at the same time more and more dissolved their communal artistic practice and communal existence. The *Chronik der Brücke* ('Brücke Chronicle'), composed by Kirchner in 1913, was seen by the other Brücke artists as unilateral, and led to the joint decision to end the group.

On the basis of the training and origin of its individual members alone, the Munich Blauer Reiter artists' association was structured very differently.

The driving force on the Munich art scene had since the turn of the century been Kandinsky, a versatile personality combining theoretical weight with an organizing ability, always able to seize on differing artistic aspirations, grasping their sense and then moulding them into his own conception. Kandinsky's activities were crucial for the development of art in Munich in the period leading up to the First World War. He succeeded in liberating the artists from the prevailing Munich academicism by founding in 1901 the Phalanx society, whose president he became. He also taught at the affiliated Phalanx school.

The starting point for Kandinsky and the Munich painters was their Academy training. Their most important teacher was Franz von Stuck (1863–1928), who in 1892 became co-founder, together

with Wilhelm Trübner (1851–1917) and Wilhelm Uhde (1874–1947), of the Munich Secession, which very successfully represented the official art, accepted and tolerated by society. In 1913, Julius Meier-Graefe wrote of Stuck: 'His work was based on amusing emblems, menu decoration twirls. He did everything that could be used for cheerful masquerade, for modern colours and new sunspots, Lucifer and sin, the celebrated snake and the guardian of paradise with the darting sword. The mermaids which at first decorated the borders swelled to Böcklin-like bodies with Munich faces. He made sphinxes of waitresses, and waitresses of sphinxes.'[8]

The liberation from academic attitudes and the radical new beginnings were largely due to the circumspection and impulses of Kandinsky. In 1909 the Munich artists formed the Neue Künstlervereinigung München ('Munich New Artists' Association'). Founding members, apart from Kandinsky, the chairman, included his compatriots Jawlensky (vice-chairman) and Marianne von Werefkin (1860–1938), and also Gabriele Münter, Alfred Kubin, Adolf Erbslöh (1881–1947), Alexander Kanoldt (1881–1939), Heinrich Schnabel, and Oskar Wittenstein. They were even entered in the Munich societies register.

The members sought to establish a suitable platform for their artistic ideas, both in order to set themselves apart from the already socially accepted Munich Secession, and in order by means of exhibitions to bring their artistic endeavours to the attention of as large a public as possible.

The inclusion in the Munich societies register indicates the extent to which the artists managed to conform and submit to the social norms and conventions outside their artistic activities, even when their work was specifically designed to combat the way in which art and bourgeois society played into each other's hands.

The ideals of obedience, duty, and order, which in the course of the Wilhelminian era had become more and more encrusted and fossilized, were questioned not through spectacular gestures—Baroness von Werefkin, for instance, held a salon typical of the time—but through artistic activities, and the gradual gaining of acceptance with the public. This was also illustrated by the association's first exhibition, in 1909, which was a failure, bringing down on them the indignation and mockery of visitors and the abuse of the press. On the occasion of the second exhibition, too, in 1910, where the most celebrated French artists were shown, including Picasso, Braque, Derain, and Vlaminck, official criticism spoke of an 'absurd exhibition', apparently 'incurably deranged' artists and 'bluffers'.

The polemical *Protest deutscher Künstler* ('Protest of German Artists') published by the painter Carl Vinnen (1863–1922) on 1911, which was in particular directed against the high regard for French art, its influence, and its purchase by German museums and collectors, indicates how strong the conservatives amongst the artists felt, how powerful the artistic reactionary element believed itself, and how far it saw its position questioned by the new developments in art. Declarations of approval came not only from Academy professors, but also from, for instance, members of the Munich Secession.

The riposte, inspired by Marc (who, interested by the second exhibition of the Neue Künstlervereinigung, had joined it in 1911) and Kandinsky, was a vehement defence of a progressive, modern concept of art. It included contributions, apart from those of Marc and Kandinsky, by Amiet, Max Beckmann, Corinth, Liebermann, Max Slevogt, Christian Rohlfs, Gustav Klimt (1862–1918), and other artists, as well as by the art historians G. Pauli, Wilhelm Worringer, W. Hausenstein, the director of the Hamburg Kunsthalle Alfred Lichtwark, the founder of the Folkwang Museum Karl Ernst Osthaus, and the collector Wilhelm Uhde.

This discussion drew on both sides on considerations and arguments based on art history, art

theory, and aesthetics, and thus remained, both in its starting point and its direction, essentially restricted to art. At the same time, this event clearly indicates the extent to which the art scene, in spite of being centred on Berlin and Munich, had long since taken on a supra-regional character. The public interest in the new art had in the meantime become so large that in 1912 Osthaus was able to publish a catalogue of works in the Folkwang Museum founded by him in Hagen in 1902 (it was later moved to Essen), in which the best known of the works which he had bought by Auguste Renoir (1841–1919), van Gogh, Gauguin, Matisse, and Auguste Rodin (1840–1917) were listed. He was concerned to 'win our art-abandoned industrial area of the Rhur for modern artistic creation'. Since Kandinsky had for some time believed that the work of the Neue Künstlervereinigung was coming to a standstill, and resting too much on its achievements, he finally used a pretext for leaving the association with Marc and Gabriele Münter at the beginning of the third exhibition at the end of 1911. Marc wrote to Macke, in a letter dated August 10, 1911: 'I recently had to go to Munich to a committee meeting—Erbslöh, Kanoldt, Dr. Wittenstein, and myself—and had the opportunity of seeing Kanoldt's *Summer Works*. You cannot imagine how depressed I was as I returned home . . . , such a ridiculous and banal imitation of fashionable Cubist ideas, you make a fool of yourself just exhibiting something like that.'[9]

These three—Kandinsky, Marc, and Münter—then founded the association 'Der Blaue Reiter'. The name was taken from the almanac *Der Blaue Reiter* which had been in preparation by Marc and Kandinsky, together with Macke, since 1911, and was published by the Piper-Verlag in 1912.

The foundation of the Blaue Reiter was probably Kandinsky's most important initiative. The subsequent development of Munich Expressionism took the form of a kind of selection procedure—Klee, Macke, Jawlensky, Marianne von Werefkin, Kubin, and Campendonk (who on Marc's invitation moved from Krefeld to Upper Bavaria in 1911) all joined the group, so that a kind of historically significant artistic selection occurred, rather similar to that of the Brücke.

In the catalogue of the first exhibition of the Blaue Reiter, in the Galerie Tannenberg (where the Neue Künstlervereinigung also exhibited) in December 1911, it was emphasized that the intention was not 'to propagate ONE precise and special form', but rather 'to show, through the variety of the represented forms, how the inner desire of the artists takes many different forms'[10]—in other words, they wanted an association of artists, held together simply by common or similar interests on artistic questions, while each member at the same time continued on his own path. In accordance with this concept, the group's exhibitions included—as in previous years—works not only by members of the Blaue Reiter, but also pictures by Henri Rousseau (1844–1910), Robert Delaunay (1885–1941), and the composer Arnold Schoenberg (1874–1951), who dabbled in painting.

In his short essay 'Die "Wilden" Deutschlands' ('The "Savages" of Germany'), published in *Der Blaue Reiter*, Marc formulated the idea that the Expressionist battle was waged only in the sphere of art.

'In this time of the great struggle for a new art, we fight like disorganized "savages" against an old, established power. The battle seems to be unequal, but spiritual matters are never decided by numbers, only by the power of ideas.

'The dreaded weapons of the "savages" are their *new ideas*. New ideas kill better than steel and destroy what was thought to be indestructible. Who are these "savages" in Germany?

'For the most part they are both well-known and widely disparaged: the Brücke in Dresden, the Neue Sezession in Berlin, and the Neue Vereinigung in Munich.'[11]

In other words, Expressionist art is, like most art, not a revolutionary art, but, at least in its claims,

an important part of an artistic revolution in the sense that it overturns our visual perceptions and our whole visual culture.

What is meant by 'Expressionism'?

What kind of painting was it that gave rise to the words 'Expressionism' and 'Expressionist', and which in Nazi Germany formed the major part of what was attacked as 'degenerate art'? What is meant by the word 'Expressionism'?

It cannot, for instance, simply be equated with 'expressiveness'. The works of Matthias Grünewald (c. 1475–1528), El Greco (1541–1614) or Francisco Goya (1746–1828) can all be said to share a certain kind of expressiveness—but this does not make them examples of Expressionist art.

Expressive manners of portrayal have recurred throughout the history of Western art, while 'Expressionism' was the word coined by contemporary professional and lay observers to describe a stylistic phenomenon at the beginning of this century, which accorded particular importance to artistic expression

In ordinary usage, we talk of 'expression' in the sense of expressing oneself in a certain kind of way—to express oneself elegantly, or coarsely; or to express one's respect, or regret (about something). In our daily lives, we are constantly expressing ourselves in a particular way. The farmer expresses himself as a farmer, in his direct dependence on the seasons, the weather, the soil, and so on. Likewise a technician, a teacher, or an artist, in their respective actitivies. The artist is especially concerned with human relations and their expression; he explores them, and in his art he transforms them, using his own artistic means of expression to enable us, as observers, to distinguish different modes of expression, by means of an artistic model, or paradigm, and both to become involved with and to take a critical stance towards them. We express ourselves through direct contact with objects, when we see or touch something, when we use tools, and so on, and also through gestures, words, or looks. Equally, we can express ourselves on a pictorial surface with or in lines, forms, colours, or with signs (i.e. semiotically). We cannot avoid expressing ourselves, any more than we can avoid coming into contact with different objects.

We may distinguish between detachment and engagement, objectivity and subjectivity, in our daily life. The absolute belief in objective possibilities of expression, as explored by realist and Impressionist art through the portrayal of our relation to the visible world, was formulated by the French positivist philosopher Hippolyte Taine thus: 'I wish to reproduce objects as they are, or as they would be even if I did not exist.'[12] The practical pursuit of this aim may be seen in Impressionist painting, in techniques conveying shimmering heat, or the effect of the light at certain times of day (as in Monet's *Notre Dame* series), where one particular quality—e.g. the atmosphere—is preserved. This mode of expression, created by the use of certain artistic techniques, may, together with other (e.g. naturalist or realist) styles, be described, like our ordinary relation to objects, as detached, or objective. On the other hand, we find different kinds of engagement, where a certain attitude is taken up with the most radical kind of self-assertion, with the aid of an artistic style, where it is not the different aspects of the objective reality, but our own possible relation to that reality, which forms the artist's principal concern. The degrees of greater or lesser detachment or engagement are thus greater or lesser deviations of different kinds. The distinction between a more Impressionist and a more Expressionist

portrait does not consist in *how much* is retained in the painting, but rather in the *manner* in which the artists have approached and interpreted their subjects—in other words, it is a question of the respective artistic styles and manners of execution.

When this subjective 'expressiveness' is taken to its extreme, when it is treated as the only possible mode of expression, then we may speak of an Expressionist manner. But it should not be forgotten that the term 'Expressionist painting' is not a general conceptual definition, but specifies one style in twentieth-century painting, limited to one historical period. The common characteristic features of the Expressionist style in painting are embraced by the term 'Expressionism', and in this sense represent a unique artistic movement. Artists who produced pictures in this style are called Expressionists. Our task here is to describe the characteristic features of Expressionism, in order to show the extent to which it is distinct from other styles of painting, and also to discover which of these characteristics are specific to Expressionism, so that we may see which are the determining features which justify the existence of an individual name for the phenomenon.

With the help of these characteristic features and their categorization, we can then examine what attitudes and what pictures have formed the basis of the discussion of Expressionism. It should not be forgotten that Herwarth Walden, the great patron of the artistic avant-garde, was not alone in seeing Expressionism as a turning point in art, the beginning of a new era. Hence we must consider whether it was indeed a turning point—and, if it was, whether it produced something that was merely partly new, a new variant of something familiar (as with Impressionism and Neo-Impressionism, for example), or whether the movement represented some kind of genuinely radical change.

Principles and directions of the new vision

From the point of view of subject matter, Expressionist paintings are almost conventional in terms of modern art since the French Revolution and the abandonment, inconographically speaking, of subjects from Christian and mythological tradition. We find the whole range of themes which had replaced the old canon: portraits (and self-portraits), landscapes (including urban landscapes), nudes, and still-lifes. Thus we have titles like *Male Portrait* (Ill. 20), *Man with Flower* (Ill. 38), *Variations on a Human Face* (Ill. 41), *Portrait of Rainer Maria Rilke* (Ill. 67), *Self-portrait* (Ill. 65); *Landscape in Dangast* (Ill. 36), *Landscape with Houses* (Ill. 43), *Apple Trees in Blossom* (Ill. 18); *Recumbent Blue Nude with Straw Hat* (Ill. 23), *Naked in a Room: Fränzi* (Ill. 24), *Adam and Eve* (Ill. 29); *Bunch of Autumn Flowers* (Ill. 62), *Still-life with White Vase* (Ill. 37), or *Exotic Figures* (Ill. 31).

The depiction of animals, particularly in Marc's work, is also not new, thematically speaking: in other words, the 'what' in these paintings is nothing startling.

In this connection it should be pointed out that there is hardly a single example from the Expressionist decade of an artist commenting, through his choice of theme, on the social or political conditions of the time. Painting as a political weapon was a concept foreign to the Expressionists. Even the more socially critical works of Käthe Kollwitz (1867–1945) or Franz Masereel (1889–1972), who were both primarily graphic artists, were—inasmuch as their work was being produced at the same time as that of the Expressionists—more in the nature of exceptions, if we discount the direct effects of Expressionism on painters immediately after the First World War, including politically conscious artists such as those represented here, Otto Dix (Ills. 74, 75) and George

Grosz (Ills. 76-8). Present-day politicization, with its frequent basic misconception of the task and function of artistic activity, means that art is only accepted on the basis of its alleged political commitment, and much of the work of the Brücke and Blauer Reiter artists is ignored. In answer to the question how art is able to pave the way for social change, the artists of 'Neue Sachlichkeit' and so-called 'Magic Realism' are adduced as illustrations and seen as far as possible in terms of their whole historical background.

The composition of Expressionist pictures is also often familiar; see, for instance the diagonal in Schmidt-Rottluff's *Landscape in Dangast* (Ill. 36), filled by a path leading from the bottom left to the top right of the picture, or in Kirchner's *Recumbent Blue Nude with Straw Hat* (Ill. 23), or Kandinsky's *Landscape with Houses* (Ill. 43). Two-figure compositions abound, familiar from friendship pictures of Romanticism: see Mueller's *Gypsy Couple* (Ill. 28), Nolde's *Candle Dancers* (Ill. 33) and, in a sense, Marc's *Two Cats* (Ill. 53) and *Sheep* (Ill. 52).

Their painting technique also, superficially at least, has nothing especially progressive about it, when seen in terms of the already existing *plein-air* painting. A spontaneous technique with some *impasto* application prevails, without any special priming or even glazing.

Given that painting and its development are connected with a change in our way of seeing things, then we must ask ourselves a double question: firstly, how, and under what circumstances, were changes of vision stimulated by the prevailinag conditions at the beginning of the twentieth century, and secondly, how did the change in vision affect painting manner, and thus pictorial organization, so that the pictures ultimately document these changes in ways of seeing things? The writer and critic Hermann Bahr commented: 'The history of painting is nothing but the history of vision—or seeing. Technique changes only when the mode of seeing has changed. It changes so as to keep pace with changes of vision as they occur. And the eye changes its method of seeing according to the relation man assumes towards the world. A man views the world according to his attitude towards it.'[13]

As far as the first part of the question is concerned: Expressionism is justly seen as the last great European artistic revolt. But who is its battle cry directed towards? The Worpswede Jugendstil painter Heinrich Vogeler (1872–1942), who later turned to socialism, writes that it was the 'passionate attempt' to 'liberate oneself from everything outdated in bourgeois art, an attempt to destroy the old'.[14]

Marc speaks of the battle against 'established power'. Typical of 'the old' was the domesticated society, industrial and capitalist inhumanity, as revealed in the annihilation of man as an individual, and the objectification of his labour, in the bureaucracy of the authoritarian state. Excellent literary treatments of the theme occur in Gerhart Hauptmann's *The Beaver Fur* (1893), or Carl Sternheim's *The Trousers* (1911), the first of a series of eleven plays which Sternheim published between 1911 and 1922, under the collective title of *Aus dem bürgerlichen Heldenleben* ('From the Bourgeois Hero's Life'). The pomp of the representational art of the Wilhelminian ruling class and the drowning of the individual in the industrial and cultural achievements of civilization went together with a deadening of vision and of perception through the photographic boom, the esotericism and aestheticism of *art nouveau* at the turn of the century, and the uncommitted 'neutral' position of the Impressionist 'art of the moment'.

The revolutionary impetus of those who sought to question and overcome the prevailing social norms developed particularly within the middle-class philosophy and view of art, which dared to wage open warfare, as the Vinnen quarrel mentioned above indicates. The slogan of 'sachliche Humanität' ('objective humanity') was coined against this new background, and represented an attempt, through

the reform of all man-made products, to have a humanizing influence and to fulfil the principle of absolute equality among men, in order to introduce new, more contemporary forms of human co-existence. The city became a new form of life. In 1907 the call for 'objective humanity', which among other things sought to provide a kind of mediation between art and industry, partly materialized into the German Werkbund (labour league)—an organization which successfully continues its work up to the present day, as was impressively illustrated by the exhibition 'Between Art and Industry—The German Werkbund' in the Munich Neue Sammlung in 1975. The problems of the time were summed up by Alexander Schwab in 1930: 'One of the most remarkable phenomena of European intellectual history remains the way that an aesthetic conscience suddenly developed in England, Germany, and Austria around the turn of the century. This statement contains an intrinsic paradox, which which we must understand in order to appreciate its full significance: conscience was aroused, conscience in its proper sense—social conscience, moral conscience, or whatever one chooses to call it—but the conscience pangs were caused by a sense of aesthetic dissatisfaction. Bourgeois society saw everything it had made, and, behold, it was very ugly.'[15]

One might sum up the 'organized' conditions against which the 'objective humanity' rebelled by saying that the life and behaviour of man after the turn of the century was admittedly protected, but was at the same time restricted by rules, prohibitions, and norms. Hermann Bahr comments on the effects of this on taste, feeling, and perception: 'The child, even before a work of art can please or displease him, is taught what should please, what should displease him, so that his own feeling does not dare to reveal itself, but always has to ask the mind, trained according to certain precepts, for permission.'[16]

Another movement wanted to get away from this normative ossification through individualistic flight as 'healing through the spirit', as self-redemption through the intensification of the personality.

And, lastly, a third direction should be stressed: art's relation to science. Science was moving away from the analysis of the existing to the analysis of that with which the existing can be examined. Just as science, as the logic and theory of knowledge, was beginning to pay attention to signs, in order to pursue its scientific business at all, so art, too, began closely to examine visual images, as created and produced on a flat plane as signs fulfilling a portraying function. Art thus became essentially *semiotic*, like science, and followed a parallel course to the latter.

But whereas science and philosophy, on the principle that 'our theoretical understanding always outstrips our practical capacity', moved away from the direct activity of daily life and threatened to become lost in a mass of empty abstractions, art succeeded in finding a new sensual base by rediscovering the creative process 'from scratch'. Instead of motifs and imitation, it sought to trace painting techniques back to the basic composition features, the quintessential elements of painting. Thus the painting processes began to be emphasized, creating a significantly new kind of artistic practice. 'If my works sometimes create a primitive impression,' wrote Klee, who was especially interested in the painting of children and mentally ill people, then that primitiveness is based on my discipline: constant reduction. It is simply economy, i.e. the latest professional perception—in other words, it is the exact opposite of true primitiveness.'[17]

We see in the pictures of the artists how they gradually reverted from the perfectionist application of objective representational canons to the 'scrawling' stage; from here they take the first independent steps in producing forms and colours, and make the sequence of steps visible to all, so that we can take an active part in these sensuous discoveries at their various stages.

22

The expressionist manner of painting

Twentieth-century art has taught us one distinction which has remained crucial up to the present day—distinction between on the one hand, the *material* (in the case of painting, the canvas, frame, colours, brush, and so on) and, on the other, the use of painting techniques which in turn lead to the pictorial organization. As far as the material is concerned, the Expressionists' works show that they felt themselves naturally tied to the materials of traditional painting. It would no more have occurred to them to abandon easel painting as the standard, than to use non-artistic materials and objects in their pictures, as was to become a significant artistic innovation, with the use of collage, material pictures, and object art. Another indication of their traditionalism was their vigorous development of the woodcut—especially by Munch and the Brücke artists—which thus blossomed anew.

The painting techniques and their treatment need examining in closer detail—as was done briefly with Fauvism—in order to be able to discuss the pictorial organization of Expressionism and its aims.

At the same time, it should not be forgotten that the methods used for or in the activity of painting cannot be seen independently of this activity: the artistic means and technique result in the artistic activity, the picture itself. It is impossible to separate the artistic means from their use or from the result of this use. Thus, for example, the use of luminous paint in the painting of the sixties represents an innovation both in terms of materials and methods, as does the use of the spray gun.

Whereas all realist painting, including Impressionism, treats the subject matter of the painting as pre-existent to the creative act, as something that can be 'verified by nature', the Expressionists aimed more and more at organizing the picture so that it would become clear to what extent the motifs of the visible world were first and foremost the result of a way of looking at it and the artistic act an extension of this.

The uncouth and unruly style of these pictures shocked the contemporary observer. The paintings were literally composed of dabs of paint which combined to make colour masses and forms, with apparently uncontrolled brushstrokes, so that critics said of them that the artists attacked their canvases with paint and brush. Consequently, shading and halftones, and the use of one colour as a colour intrinsic to the object in question is avoided. The approach familiar from the Fauves' work is thus taken to its extreme. The dry, often unmixed colours startle the observer, and, in addition, every contrast is permitted. Whereas the Fauves essentially retained the framework indicated by the depicted objects and made the colours go beyond the bounds of objective forms, the Expressionists accentuate their relation to colour by creating objects which only come to exist in and through colour. This then gives the whole composition a firm strength. The existence of the objective details is entirely dependent on the use of colour, and the details are merely sketched in and reduced to a few typical characteristics. The limiting of the colour masses as colour forms—Kirchner developed a jagged pattern into his own painting script—is often held together by an equally brightly coloured, large, angular, often unwieldy outline, which keeps the different objects and colours bound into separate colour masses. The shades of colour to be found in both Marc's and Lyonel Feininger's works within the partly geometrical colour masses cannot be seen as object-related; rather, they exist as variants within the colour form.

This technique of composing the picture only of elements and fragments intrinsic to the picture can be called an essentially assembling method of building up the picture, thus a *synthetic* approach, in contrast to the *analytical* approach of the Impressionists, with their dissection of the objective subject.

This synthetic method is particularly reinforced by the fact that a previously unknown freedom of form, enabling each picture to be created anew, endeavours to make the creative process visible within the picture itself, in that the pictorial organization is not simply dependent on the painter, but only becomes visible in its completed form. In other words, the picture always manifests its character in such a way that we are not presented with an over-perfect picture, satisfying all the current norms of art as accepted by the observer—in which case a kind of automatism of perception follows. The picture always indicates the way it has been prepared and organized, and thus directly unveils the unconventional intention of the underlying artistic approach. These factors mean that the pictorial object builds up in the picture as an 'individual figure' (A. Gehlen), and more and more becomes liberated from the objective motifs of the visible world. The Expressionist painter's action is thus primarily directed towards the successive examination and exploration of the painting methods in their creative quality; he becomes more and more interested in sign-like 'interpolations', as Ernst Cassirer described them, and less interested in the objects and motifs of the visible world.

In the spring of 1911, as stated in the foreword to the catalogue for the third exhibition of the Neue Sezession (in which Nolde and Rohlfs as well as the Brücke painters took part), the organization of a picture according to these methods became part of their programme:

'Decoration derived from Impressionism's idea of colour: that is the programme of young artists in every country; i.e. they no longer take their rules from the object, of which it was the ambition of the Impressionists to obtain an impression through pure painting; instead, they think of the wall and for the wall, and in terms of colour. . . . Areas of colour are placed side by side in such a way that the incalculable laws of balance imposed by colour quantities abrogate the rigid, scientific laws of colour qualities with a new personal freedom of movement and expansion of available space. These areas of colour do not destroy the basic lines of the objects represented, but line is once more consciously used as a factor, not to express or shape forms, but to describe forms, to characterize the expression of a feeling and to place figurative life firmly on the surface. Through the fact alone that everything objective remains on this plane, its significance is completely negated. Each and every object is only the channel of a colour, a colour composition, and the work as a whole aims, not at an impression of nature, but at the expression of feelings. Science and imitation disappear once more in favour of original creation.'[18]

The most important consequence of the constant exploration of artistic means as images independent of any intention to depict motifs of the visible world, was the first abstract or concrete picture, painted by Kandinsky in 1910 (Ill. 44), where the character of the painting act becomes manifest. This forging ahead into a field hitherto unknown in art should not be confused with, for example, the late water-lily pictures of Monet or with the decorative experiments of *art nouveau*, which had quite different aims, even if the results might incline us to talk in similar terms of non-objective representation. For if an objective manner of representation—e.g. the portrayal of light and atmosphere—is, as in Impressionism or in Turner's work, taken to its furthest extreme, then the objective depiction may cease to be objective, against all one's intentions. No doubt the Expressionists learnt through the Impressionists to see the disintegration of the object, but they used this disintegration in very different ways.

Attitudes to the pictures of the artistic revolt

What is the modern observer's reaction to pictures organized in this way? Or, to put the question in

another way: are they for us now anything more than the historical documentation of an artistic revolt?

A statement by the photographer Edward Steichen is perhaps relevant in this connection: 'Photography relieved painting of the necessity of being objective.'[19]

What pictures were conventionally supposed to suggest is most easily seen in photography, which enjoyed a boom at the beginning of the century. Photographic studios were a lucrative business, and their owners often called themselves 'artistic photographers'.

The slogan for the photos produced here was their 'unsurpassed lifelike quality'. Photography thus became the heir to all realist manners of portrayal, and the likeness was perfected to such an extent that the subject could always recognize himself afterwards ('that was me when I got confirmed', and so on), and could also always be recognized by others. This 'faithful likeness', unique to photography, gradually became the most important criterion for the function and quality of pictures.

The photograph as a consumer article (as it had become since about the turn of the century) thus constantly suggested that the main purpose of pictures was to allow recognition, and to serve as an aid to memory. The more the photo on a 'Wanted' poster helped to find the wanted man, for instance, the better the photo. Not even the best description could replace such a picture. Detail, completeness, and so on, were therefore of the utmost importance.

As photography essentially helped to establish images as objects for the purpose of recognition and memory, it was easy to come to believe that all pictures were more or less designed for the same ends. Very few people gave any consideration to the fact that the portrait photograph of the turn of the century placed the subject in the pomp of the representational style of the photo studio, and encouraged him to strike absurd and completely unnatural poses.

As early as 1896, Lichtwark had commented: 'If a later age gets hold of a copy of a portrait photograph from our time, they will say: what a barbaric race, with the need to pose, with no feeling for emotion, or character—a dull, pusillanimous race.'[20]

The Expressionist theorist Kasimir Edschmid, too, formulated the curt antithesis: 'They did not see, they looked. They did not photograph, they had faces.'[21]

Instead of simply being an aid to recognition and memory, pictorial composition and technique could now be based on quite different considerations. They could be upsetting and chilling, they could be cutting, provocative, or aggressive—e.g. in satirical portrayal or caricature. The picture now aimed not to make the observer recognize the subject as something entirely familiar, but to encourage him to perceive it in such a way as to make him see it as though for the first time ('I've never seen it (or him) like that', or 'to think that it's possible to see that/him like that!). This can for instance occur if the composition directs our attention especially towards the manner of execution. We may thus, bearing Steichen's words in mind, proceed to an examination of Expressionist pictorial organization.

In their formulaic manner of portrayal, the Expressionist painters limited themselves to providing sufficient detail for the observer to be able to distinguish, for example, jugs, flowers, and trees, or to distinguish horses in a meadow from sky and clouds. In other words, they were not concerned to paint the fluttering foliage on trees in such a way that it would be possible to count every leaf. It was not their intention to be objective in this sense. For them it was entirely sufficient to be able to recognize a path as a path, a naked man as a naked man, and they were not concerned that we should, for example, be able to distinguish the marks left by a cart on the path, or the glistening skin of a naked body. Equally, they were not concerned with portraying a nude, for instance, with all the attendant

pomp and social majesty; they 'undress' man of all these trimmings, and show how they see our relation to nakedness: a natural, simple, and inevitable condition. The same applies to illness and death, and one might particularly point to the relation between nude and landscape, already present in Cézanne's late work.

This return to conditions free of civilized and social relations, and thus in this sense natural conditions, was partly inspired by the interest in the art of primitive peoples, in particular in Negro plastic art, as illustrated in, for example, an impressive illustrated volume published by Carl Einstein in 1915. Kirchner had in 1904 discovered the famous Palau beams in the Ethnology Museum in Dresden.

In the search for the natural life, untainted by culture and civilization, Pechstein in 1913 followed Gauguin to the South Sea Palau Islands, and Nolde set off for New Guinea. Nolde described the motivation for such journeys: 'The absolute primeval quality, the intense, often grotesque expression of force and life in its simplest form—perhaps that is what makes us feel joy in native works of art.'[22]

But if the artists were not concerned with details, then what was the point of the landscapes, faces, still-lifes, and nudes? The question is perhaps best answered by referring to a linguistic analogy.

From examples of dogs, we have learnt the word 'dog' as a linguistic sign. Equally, we have learnt that a stray, mangy dog of any breed is described as a 'cur', i.e. the use of the word 'cur' generally indicates an animal of scruffy appearance and condition. A person can, however, use the word for any dog—in other words, independently of the behaviour and appearance of that particular dog. By applying the word 'cur' to any dog he expresses his feelings about dogs in general—the use of the word 'cur' in this context gives us almost no information about dogs or one particular dog, but tells us a great deal about the relation of the speaker to dogs. It is possible for a speaker, or someone who uses pictorial or visual signs, to express not only his negative attitude to animals, persons, or objects, but also, to the extent to which the signs permit, to express any kind of relation in this way.

The Expressionist painter's use of the visual signs at his disposal is similar to the use of the word 'cur' in the above analogy. For his intention is not to give more detailed information on houses, flowers, naked women, and so on, but to attempt to give information on how he sees man's relation to the world. In other words, the use of the pictorial means is not to be measured against the portrayed object in the visible world, but in terms of the artist's particular relation to it. In order to succeed in this aim—and not, for instance, in order to distort the objects, not in order to 'rape the sense world' (Bahr)—he omits all inessential details, and avoids giving the most detailed depiction possible. This concept, when logically developed, means that he is able to abandon the direct relation to the visual world entirely. Thus, in Kandinsky's pictures we find his attitude to the visible world expressed in its fairytale-like enchantment (Ill. 44), while Nolde's work reveals the incalculable force of the elements (Ill. 30), and Heckel's the delicacy and fragility of man's relation to nature (Ill. 22).

The Expressionists became free from all realistic manners of representation by leaving this to photography; their paintings became individual patterns of how we can see the world *with our own eyes*, if we care to.

Since the images created by this way of seeing things and by these techniques not only belong to the ordinary world, but also enrich it with a new way of seeing, it cannot be said that the painters, who ceased to concern themselves with differences and classifications in our relation to the visible world, had irresponsibly retired or isolated themselves from our common world. Rather, on the basis of their new way of seeing reality, they discovered a new theme: the many differing attitudes and relations to the world, and a new world within painting.

Expressionism as the beginning of an era brought no essential innovations in its basic adherence to

thematic conventions and the materials of traditional painting. Its radicalism stemmed from its discovery and exploration of a new artistic manner, which led to a new organization of the picture on the surface. Thus Expressionism quite unexpectedly provided an answer to the question of how attitudes to the world which were not yet conventionalized could be made tangible. It showed how the action of painting could best be demonstrated by making the process of painting itself the subject, so that the observer accustomed to technically perfect pictures is battered by the aggressiveness of familiar painting techniques taken to their extreme. Here we have the true subject of all twentieth-century art: artistic activity as a paradigm of experience and free activity without prescribed norms—and man himself, the being who is able, through his creation and use of signs, essentially to form and to change the world in its appearance and its pattern.

It was in this sense that Ernst Cassirer, the philosopher of 'symbolic forms', described man as 'animal symbolicum'.

Notes to the Introduction

[1] K. Pinthus, *Menschheitsdämmerung—Symphonie jüngster Dichtung*, Berlin, 1920.

[2] F. Roh, *Nachexpressionismus*, Leipzig, 1925; E. Utitz, *Die Überwindung des Expressionismus*, Stuttgart, 1927.

[3] *Ensor—ein Maler aus dem späten 19. Jahrhundert* (exhibition catalogue of the Württembergischer Kunstverein, Stuttgart, 4 March–7 May 1972), p.98.

[4] H. Walden, *Einblick in die Kunst*, Berlin, 1917, p.170.

[5] *The* Blaue Reiter *Almanac*, ed. W. Kandinsky and F. Marc, new documentary edition, ed. K. Lankheit, London and New York, 1974.

[6] L. Hevesi in a review of the Kunstschau, May 31, 1908.

[7] L.-G. Buchheim, *Die Künstlergemeinschaft Brücke*, Feldafing, 1956, p.45.

[8] J. Meier-Gräfe, *Wohin treiben wir*, Berlin, 1913, II p.710.

[9] L.-G. Buchheim, *Der Blaue Reiter*, Feldafing, 1959, p.35.

[10] Introduction to *Der Blaue Reiter*, exhibition catalogue of the Städtische Galerie im Lenbachhaus, Munich, 1963.

[11] *The* Blaue Reiter *Almanac*, ed. K. Lankheit, p.61.

[12] Hippolyte Taine, quoted in S. Kracauer, *Nature of Film, the Redemption of Physical Reality* (London, 1961), p.5.

[13] H. Bahr, *Expressionism*, London, 1925, p.37.

[14] Quoted in R. Hamann, J. Hermand, *Stilkunst um 1900*, Munich, 1975 (2nd ed.), p.216 (*Epochen deutscher Kultur von 1870 bis zur Gegenwart*, vol. 4).

[15] *Zwischen Kunst und Industrie. Der deutsche Werkbund*, exhibition catalogue of Die Neue Sammlung, Staatliches Museum für angewandte Kunst, Munich, 1975, p.11.

[16] H. Bahr, *Expressionism*, pp.12–13.

[17] Quoted in *Paul Klee*, documentation of an exhibition, Kunstsammlung Nordrhein–Westfalen, Düsseldorf, October 31, 1975–January 4, 1976, p.43.

[18] Quoted in W.-D. Dube, *The Expressionists*, London, 1972, p.159.

[19] Quoted in O. Stelzer, *Kunst und Photographie. Kontakte—Einflüsse—Wirkungen*, Munich, 1966, p.150.

[20] Quoted in P. Pollack, *The Picture History of Photography*, New York, 1958.

[21] 'Über den Expressionismus in der Literatur und die neue Dichtung', in *Tribüne der Kunst und Zeit*, Berlin, 1919, p.51.

[22] E. Nolde, *Jahre der Kämpfe. Das eigene Leben (II, 1902–14)*, Cologne, 2nd ed., 1967.

Index of quotations in the text to the illustrations

W. Augustiny, *Paula Modersohn-Becker*, Gütersloh, 1960.

L.-G. Buchheim, *Die Künstlergemeinschaft Brücke*, Feldafing, 1956.

W. Kandinsky and F. Marc (ed.), *The* Blaue Reiter *Almanac* (new documentary edition, ed. K. Lankheit), London, 1974.

Der Blaue Reiter, exhibition catalogue of the Städtische Galerie im Lenbachhaus, Munich, 1963.

W.-D. Dube, *The Expressionists*, London, 1972.

Ensor—ein Maler aus dem späten 19. Jahrhundert, exhibition catalogue of the Württembergischer Kunstverein, 1972.

G. Grosz, Leben und Werk, ed. U. M. Schneede, Stuttgart, 1975.

W. Haftmann, *Paul Klee*, London, 1967.

W. Hess, *Dokumente zum Verständnis moderner Malerei*, Reinbeck bei Hamburg, 1956 (rde 19).

K. Hiller, 'Über die Ausstellung der Pathetiker', in *Aktion*, November 27, 1912.

K. Hofer, *Aus Leben und Kunst*, Berlin, 1952.

G. Jedlicka, *Der Fauvismus*, Zürich, 1961.

W. Kandinsky, 'Über die Formfrage', (1912), in *Essays über Kunst und Künstler*, ed. M. Bill, Zürich, 2nd ed., 1963.

E. L. Kirchner, *Davoser Tagebuch*, ed. L. Grisebach, Cologne, 1968.

Paul Klee, exhibition catalogue of the Kunstsammlung Nordrhein-Westfalen, Düsseldorf, 1975-6.

O. Kokoschka, *Schriften 1907–55*, ed. H. M. Wingler, Munich, 1956.

A. *Kubin*, exhibition catalogue of the Galerie Taxispalais, Innsbruck, 1974.

A. Loos, *Sämtliche Schriften*, Munich and Vienna, 1962.

Franz Marc,, exhibition catalogue of the Städtische Galerie im Lenbachhaus, Munich, 1963.

T. Grochowiak, *L. Meidner*, Recklinghausen, 1966.

Bernard S. Myers, *Expressionism*, London and New York, 1963.

M. Pechstein, *Erinnerungen*, Wiesbaden, 1960.

R. M. Rilke, *Sämtliche Werke*, ed. E. Zinn, vol. 1, Wiesbaden, 1955 (tr. J. B. Leishman, *Requiem and Other Poems*, London, 1949).

W. Schmied, *Neue Sachlichkeit und Magischer Realismus in Deutschland 1918-33*, Hanover, 1969.

R. Stenersen, *Edvard Munch*, Zürich, 1949.

P. Wember, *Heinrich Campendonk*, Krefeld, 1960.

Bibliography

W. Kandinsky, *Über das Geistige in der Kunst*, Munich, 1912.

E. Utitz, *Die Grundlagen der jüngsten Kunstbewegung*, Stuttgart, 1913.

H. Bahr, *Expressionism*, London, 1925.

H. Walden, *Expressionismus—die Kunstwende*, Berlin, 1918, reprinted Nendeln, Liechtenstein, 1973 (Kraus reprint).

O. Grautoff, *Formzertrümmerung und Formaufbau*, Berlin, 1919.

L.-G. Buchheim, *Die Künstlergemeinschaft Brücke*, Feldafing, 1956.

W. Hess, *Dokumente zum Verständnis der modernen Malerei*, Hamburg, 1956. B. S. Myers, *Expressionism*, London and New York, 1963.

L.-G. Buchheim, *Der Blaue Reiter und die Neue Kuństlervereinigung München*, Feldafing, 1959.

B. Zeller, *Expressionismus, Literatur und Kunst, 1910–1923*, exhibition catalogue, Marbach a.N., 1960.

Europäischer Expressionismus, exhibition catalogue, Munich, 1970.

W.-D. Dube, *The Expressionists*, London, 1972.

Short Biographies

Beckmann, Max
B. Leipzig, 1884, d. New York, 1950. Began studies at the Academy in Weimar, 1899; member of the Berlin Secession, 1906; war volunteer, 1914; teacher at the Städel Kunstinstitut in Frankfurt, 1925. Emigrated to Amsterdam, 1937, and to St. Louis, U.S.A., 1947; offered a post at the Brooklyn Museum Art School, New York, 1949.

Campendonk, Heinrich
B. Krefeld, 1889, d. Amsterdam, 1957. Studied at the Kunstgewerbeschule in Krefeld with Thorn-Prikker, 1906; moved to Upper Bavaria, joined Der Blaue Reiter, 1911; military service, 1914–18; teacher at the Kunstschule in Essen, 1922, and at the Academy in Düsseldorf, 1926. Dismissed from his post, emigrated to Amsterdam, 1933; appointment to the Rijksakademie van beeldende Kunsten.

Derain, André
B. Chatou, 1880, d. Chambourcy, 1954. Studied drawing with Jacomin in Chatou; studied at the Académie Carrière, 1898, and at the Académie Julian in Paris, 1904; took part in the Fauves exhibition at the Salon d'Automne, 1905; influenced by Cubism, 1908.

Dix, Otto
B. Untermhaus bei Gera, 1891, d. Singen, 1969. Studied painting, 1905–9; studied at the Kunstgewerbeschule, Dresden 1909–14; military service, 1914–18; appointment to the Academy in Dresden, 1927; dismissed from his teaching post, 1933; prohibited from exhibiting, 1934; arrested by the Gestapo, 1939; French prisoner of war, 1945–6.

Ensor, James
B. Ostend, 1860, d. Ostend, 1949. Studied at the Academy in Brussels, 1877–80; friendship with F. Khnopff; apparently went to London, 1892; Knight of the Order of Leopold, 1903; large exhibition of his works at the Kestner-Gesellschaft, Hanover, 1927.

Feininger, Lyonel
B. New York, 1871, d. New York, 1956. Moved to Europe, 1887; studied at the Kunstgewerbeschule in Hamburg, from 1888 at the Academy in Berlin, and 1892-3 at the Académie Colarossi in Paris; 1911 met Robert Delaunay; exhibition with the Blaue Reiter, 1913; teacher with the Bauhaus in Weimar and Dessau, 1919–33; returned to New York, 1937.

Gauguin, Paul
B. Paris, 1848, d. Atuana (South Sea Islands), 1903. Bank clerk, 1871; active as a painter, 1874; first stay in Pont-Aven, 1886; in Pont-Aven again, 1888; meeting with van Gogh in Arles; on Tahiti, 1891–3, and then in Paris and in Brittany; Tahiti again, 1895; moved to the Marquesas, South Sea Islands, 1901.

Grosz, George
B. Berlin, 1893, d. Berlin, 1959. Studied at the Academy in Dresden, 1909–10, at the Kunstgewerbeschule in Berlin and at the Académie Colarossi in Paris, 1913; leading member of the Dada group in Berlin, 1917–20; emigrated to New York, 1933.

Heckel, Erich
B. Döbeln, Saxony, 1893, d. Hemmenhofen, Lake Constance, 1970. Friendship with Schmidt-Rottluff from 1901; studied architecture at the Technische Hochschule in Dresden, 1904–5; co-founder of the Brücke; moved to Berlin, 1911; dissolution of the Brücke, 1913; sanitary orderly, 1915–18, met Beckmann and Ensor; teaching post at the Academy in Karlsruhe, 1949–55.

Hofer Carl
B. Karlsruhe, 1878, d. Berlin, 1955. Studied at the Academy in Karlsruhe with L. Thoma and L. Kalckreuth, 1896–1901; interned in France, 1914–17; professor at the Academy in Berlin, 1919–33; Director of the Berlin Hochschule für Bildende Künste from 1945.

Jawlensky, Alexej von
B. Torzhok, Russia, 1864, d. Wiesbaden, 1941. Studied with Repin at the Academy in St. Petersburg from 1889; moved to Munich, 1896; studied painting under Azbé (together with Kandinsky); co-founder of the Neue Künstlervereinigung, 1909; member of the Blaue Reiter, 1912; moved to Switzerland, 1914, and to Wiesbaden, 1921; ill from 1921, and crippled from 1938.

Kandinsky, Wassily
B. Moscow, 1866, d. Neuilly-sur-Seine, 1944. Studied jurisprudence and political economy in Moscow, 1886; studied at the Azbé School in

Munich and at the Academy under Franz von Stuck, 1897–1900; co-founder of the Neue Künstlervereinigung München, 1909; founding of the Blaue Reiter, 1911; return to Moscow, 1914; teacher with the Bauhaus in Weimar, Dessau, and Berlin, 1922–33; moved to Neuilly-sur-Seine, 1933.

Kirchner, Ernst Ludwig
B. Aschaffenburg, 1880, d. by suicide, Davos, 1938. Studied architecture at the Technische Hochschule in Dresden, 1901–5; studied painting in Munich, 1903–4; co-founder of the Brücke, 1905; moved to Berlin, 1911; war volunteer, 1914; time spent in a sanatorium in the Taunus, 1915; moved to Switzerland, 1917.

Klee, Paul
B. Münchenbuchsee, near Berne, 1879, d. Muralto-Locarno, 1940. Studied with Knirr and Stuck at the Academy in Munich, 1889–1901; in Berne, 1902–6; moved to Munich, 1906; friendship with Kandinsky, Marc, and Macke, 1911–13; trip to Tunis with Macke, 1914; military service, 1916–18; teacher at the Bauhaus in Weimar and Dessau, 1920–31; professor at the Academy in Düsseldorf, 1931; returned to Berne, 1933.

Kokoschka, Oskar
B. Pöchlarn, Austraia, 1886, now living in Villeneuve, Switzerland. Studied at the Kunstgewerbeschule in Vienna, 1905–9; in Switzerland, Berlin, and Vienna, 1909–14; military service, 1914–15; in Dresden, 1917–24, professor at the Academy from 1919; in Vienna and Paris, 1931–4; in Prague, 1934–8; in London, 1938–53, then in Villeneuve; led the seminars of the Salzburg Academy, 1953–62.

Kubin, Alfred
B. Leitmeritz, Bohemia, 1877, d. Zwickledt, Austria, 1959. Studied at the Kunstgewerbeschule in Salzburg, 1891–2; photographic appenticeship in Klagenfurt, 1892–6; military service, 1897; studied at the Schmidt-Reutte art school and under Gysis at the Academy in Munich, 1898–1901; friendly with the Neue Künstlervereinigung, 1909; joint exhibition with Der Blaue Reiter, 1912; member of the Prussian Academy of Arts, 1930.

Macke, August
B. Meschede, Sauerland (North-Rhine-Westphalia), 1887, killed in action at Perthes-les-Hurlus, 1914.

Studied at the Academy in Düsseldorf, 1904–6; with Lovis Corinth in Berlin, 1907–8; moved to the Tegernsee (Upper Bavaria) in 1910; friendship with Marc, Kandinsky, and Jawlensky; met Delaunay, 1912; trip to Tunis with Klee, 1914; exhibitions with Der Blaue Reiter from 1912.

Marc, Franz
B. Munich, 1880, d. at Verdun, 1916. Studied at the Academy in Munich with Hackel and Diez, 1900–03; resident in Sindelsdorf, Upper Bavaria, from 1909, and in Ried, Upper Bavaria, from 1914; friendship with Macke, 1910; joint publication, with Kandinsky, of *Der Blaue Reiter*, 1911; meeting with Delaunay, 1912; exhibitions with the Blaue Reiter from 1911.

Meidner, Ludwig
B. Bernstadt, Silesia, 1884, d. Darmstadt, 1966. Builder's apprentice, 1901–2; studied at the Academy in Breslau, 1903–5; fashion designer in Berlin, 1905–6; friendship with Modigliani in Paris, 1906–7; co-founder of the 'Die Pathetiker' group in Berlin, 1912; military service, 1916–18; teacher in the study workshops ('Studienateliers') in Berlin, 1924–5; teacher of drawing at the Jüdisches Gymnasium (the Jewish grammar school) in Cologne, 1935; fled to England, 1939; returned to Germany, 1952.

Modersohn-Becker, Paula
B. Dresden, 1876, d. Worpswede, 1907. Studied drawing in Bremen and at the School of Arts in London, 1892; teacher training in Bremen, 1893–5; studied at the Malerinnenschule (paintresses' school) in Berlin, 1896; resident in Worpswede from 1898; friendship with Rilke, 1900; studied in Paris between 1903 and 1906.

Mueller, Otto
B. Liebau, Silesia, 1874, d. Breslau, 1930. Studied lithography in Görlitz, 1890–94; studied at the Academy in Dresden, 1894–6, and in Munich, 1898–9; moved to Berlin, 1908; member of the Brücke, 1910; military service, 1916–18; professor at the Academy in Breslau, 1919.

Münter, Gabriele
B. Berlin, 1877, d. Murnau, 1962. Studied art in Düsseldorf, 1897; studied at the school of the Künstlerinnenverein (paintresses' society) in Munich, 1901, and at the Phalanx school there, 1902; spent

time studying in Murnau, with Kandinsky, Jawlensky, von Werefkin, 1908; co-founder of the Neue Künstlervereinigung, 1909, and of the Blaue Reiter, 1911; separation from Kandinsky, 1914; in Berlin, 1925-9; moved to Murnau, 1931.

Munch, Edvard
B. Löiten, Norway, 1863, d. Ekely, near Oslo, 1944. Studied at the School of Arts and Crafts in Oslo, 1882–3; first visit to Paris, 1885; friendship with Dr. M. Linde of Lübeck, 1902; permanently resident in Norway from 1909.

Nolde, Emil (real name Emil Hansen)
B. Nolde, Northern Schleswig, 1867, d. Seebüll, Northern Schleswig, 1956. Studied at the Sauermann school of carving in Flensburg, 1884–8; studied at the Kunstgewerbeschule in Karlsruhe, 1889; teacher at the crafts museum in St. Gallen, 1892–8; member of the Brücke, 1906; friendship with Ensor, 1911; trip via Russia to the South Sea Islands, 1913–14; in Seebüll and periodically in Berlin, from 1914.

Pechstein Max
B. Erckersbach, near Zwickau, 1881, d. Berlin, 1955. Decorator's apprentice, 1896–1900; studied at the Kunstgewerbeschule in Dresden, 1900–02, and at the Academy, 1902–6; member of the Brücke, 1906; co-founder and chairman of the Neue Sezession, Berlin, 1910; journey to the South Sea Palau Islands, 1914–15; military service, 1916–18; co-founder and chairman of the Novembergruppe, 1918; member of the Prussian Academy of Arts, 1922; banned from the Academy and the Berlin Secession, 1934; teacher at the Hochschule für bildende Künste in Berlin, 1945.

Rohlfs, Christian
B. Niendorf, Holstein, 1849, d. Hagen, 1938. Studied at the Academy in Weimar, 1874–82; teacher at the Folkwang school in Hagen, 1901; member of the Neue Sezession in Berlin, 1910–11;

member of the Prussian Academy of Arts, 1924; banned from the Academy and attacked as 'degenerate'.

Schmidt-Rottluff, Karl (real name Karl Schmidt)
B. Rottluff, Saxony, 1884, d. Berlin, 1976. Friendship with Heckel, 1901; studied architecture at the Technische Hochschule in Dresden, 1905; co-founder of the Brücke, 1905; moved to Berlin, 1911; friendship with Feininger, 1912; military service, 1915-18; member of the Prussian Academy of Arts, 1931; more than 600 works confiscated, 1938; prohibition on painting, 1941; teacher at the Hochschule für bildende Künste in Berlin, 1947.

van Dongen, Kees
B. Delftshaven, Holland, 1877, d. Monte Carlo, 1968. Moved to Paris, 1897; worked as a packer and unskilled worker in the Paris halls, and painted and sketched portraits in the cafés; exhibition at the Salon des Indépendants, 1904; Fauvist period, 1906–13; met Matisse, Vlaminck, Derain; participation in the Brücke exhibition, 1908.

van Gogh, Vincent
B. Groot-Zundert, North Brabant, 1853, d. Auvers-sur-Oise, 1890. Worked as an art dealer, 1869–76; then was a teacher and assistant preacher; studied theology in Amsterdam, 1877–8; pastor in Borinage; first artistic works; studied at the Academy in Antwerp, 1885; moved to Paris, 1886; friendship with Gauguin and Émile Bernard; moved to Arles; mentally unbalanced; in the Saint-Rémy asylum, 1889; to Auvers-sur-Oise, 1890.

Vlaminck, Maurice de
B. Paris, 1876, d. La Tourillière (Eure-et-Loire), 1958. Racing driver, musician; self-taught painter; development of Fauvism in a shared studio with Derain, from 1903; met Matisse, 1901, Picasso, 1905; participation in the Fauves exhibition; in La Tourillière from 1925.

The Pre-Expressionist Scene

Derain

Ensor

Gauguin

Munch

van Dongen

van Gogh

Vlaminck

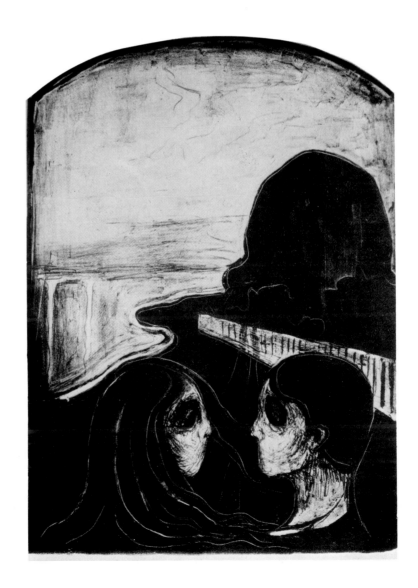

Edvard Munch
Attraction, **1896**
Lithograph, 47 × 35 cm

1 André Derain
Coastal Landscape, 1905–6
Oil on canvas, 53 × 63 cm
Ottawa, The National Gallery of Canada

'In my opinion, the great error of all painters', **Derain** wrote to Vlaminck, with whom he shared a studio during his military service in 1903, 'is that they attempted to reproduce the effect of the moment in nature. They have failed to understand that this effect is not based on anything to do with the sequence of our impressions and with painting, and they have not grasped the fact that a simple combination of brilliant colours could induce the same state of mind as an actual landscape' (Jedlicka, p.75).

The 'simple combination of brilliant colours' dominates Derain's *Coastal Landscape*, consisting of broadly applied, contrastingly juxtaposed expanses of yellow ochre, red, and violet, with a kind of perspective created by the fact that their edges meet in the upper left portion of the picture. The composition follows the familiar conventions of landscape painting, with foreground, middle ground, and background. The bushes and trees in the foreground and middle ground strengthen the sense of depth, and

(betraying the spontaneous coarse brushstroke typical of the painter's earlier Neo-Impressionist style) are painted against the powerful colour of the background in such a way that the background shows through. Unlike the Impressionists, who applied colour in tiny dabs of paint, Derain is more concerned to combine the bold colours so that these form an independent part of the composition; yellow ochre at the top and bottom, bordered by violet, with red in the middle, already suggested by the branches of the bushes in the foreground, whose green is balanced by the green brushstrokes in the upper left-hand portion of the picture. Green and blue dominated Derain's palette, together with a wide range of shades of violet, from pinkish shades to deep purple. The use of colours of equal intensity throughout the whole picture is typically Fauvist—in other words, colour perspective, with cold tones graduating into the background, is abandoned in favour of a pictorial concept much closer to the painting plane. 'As far as painting is concerned, I am conscious', wrote Derain, 'that the realist period is over. In this sense we are at the beginning. Without questioning the abstract quality of van Gogh's works, a quality which I would not dispute, I believe that lines and colours based on life are related to one another in a powerful enough way . . . to be able to find if not a new area of work, then at any rate a more realistic, and above all a simpler field of work in the possibilities of synthesis that it offers . . .' (Jedlicka, p. 74).

Dancers, first exhibited at the Salon des Indépendants in 1907, shows on the one hand the colouring which later became typical of Derain; the lack of glaring, pure colours, and the transition towards broken colours of the same tonality, which in turn led to a kind of monochrome, as in *The Forest* (1920). At the same time, we can see in *Dancers* Derain's discoveries in painting technique, where he learnt both from the old masters—Caravaggio, or Rembrandt —and from the endeavours of his contemporaries, in particular the Cubists, with whom he became acquainted through the latter's great patron, H. Kahnweiler, and

to whom he felt especially close during the following years.

2 André Derain
*Dancers, c.*1906/7
Oil on canvas, 49 × 44 cm
Paris, R. Lebel Collection

Although **Ensor** himself declared his indifference to the various artistic directions and schools, the influence of Symbolism and particularly of Turner is unmistakable. His favourite themes include skeletons, ghosts, and masquerades.

Particularly in the period around and just after 1890, Ensor painted still-lifes, usually with jugs, bottles, fishes, mussels, and crabs, and with fruit or vegetables (e.g. *The Savoy Cabbage*, 1894). Frequently he includes symbols of transience, from the 'Vanitas' tradition; a pipe, a pack of cards, or an extinguished candle. With few exceptions, all these still-lifes have the same composition. A table top, parallel to and often running along the whole of the edge of the picture, with objects scattered on it apparently at random, often with particular emphasis on the centre of the picture—in this case via the jug, which dominates the composition not only by its position but also by its colouring. The colours are densely applied, and have a pale luminosity, with light yellow and red often shining through.

3 James Ensor
Still-life with Blue Jug, **1890–91**
Oil on wood 37.5 × 45.6 cm
Stuttgart, Staatsgalerie

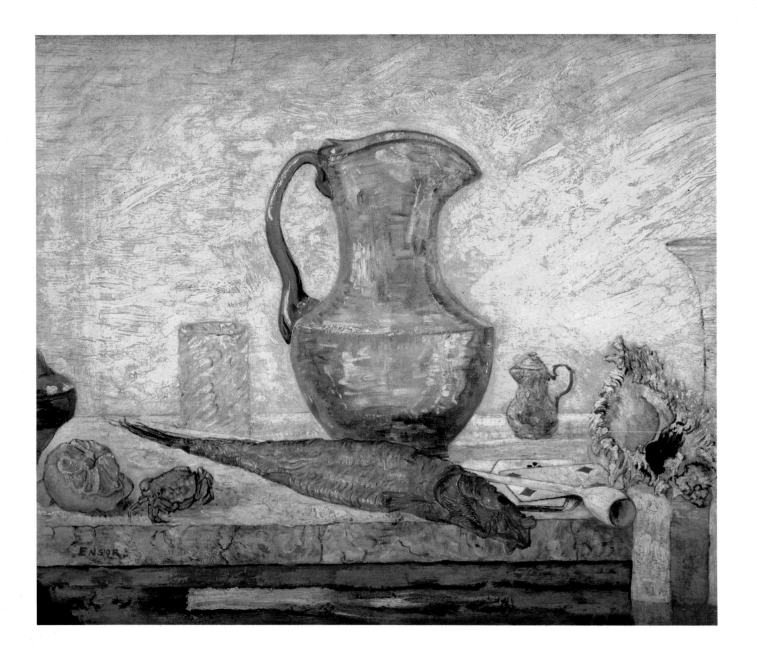

In the still-lifes, as in the mask pictures (which earned him the nickname of 'The Mask Painter'), to which he devoted himself almost exclusively after about 1900, Ensor is concerned with discoveries in the realm of colour, 'pure colour'. '"Ah!" said I, "so you don't like my brightly-coloured masks! Very well then, I shall take cinnabar-red and cobalt blue and lemon yellow!... Like it or not, I shall give you pure colour tones!"' (Ensor catalogue, p.100).

The constant depiction of masks—they occur in the still-lifes, too—support this artistic concept, in that they free the artist from the restriction of conventional themes, and virtually demand 'freshness of tone' and 'grand setting'. But at the same time they make possible the 'exaggerated expression' which gives Ensor's pictures their simultaneously repellent and curiously fascinating character, presenting us with the mask-like quality of man, often leaving ambiguous whether the figure depicted is simply wearing a mask, or whether its face is itself frozen into a mask.

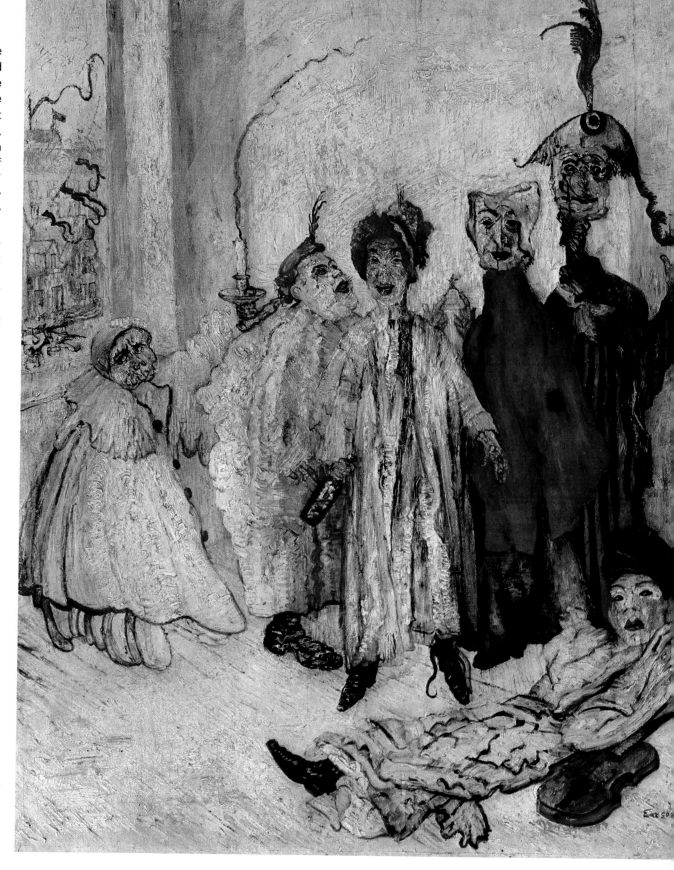

4 James Ensor
Strange Masks, **1892**
Oil on canvas, 100 × 80 cm
Brussels, Musées Royaux
des Beaux-Arts

37

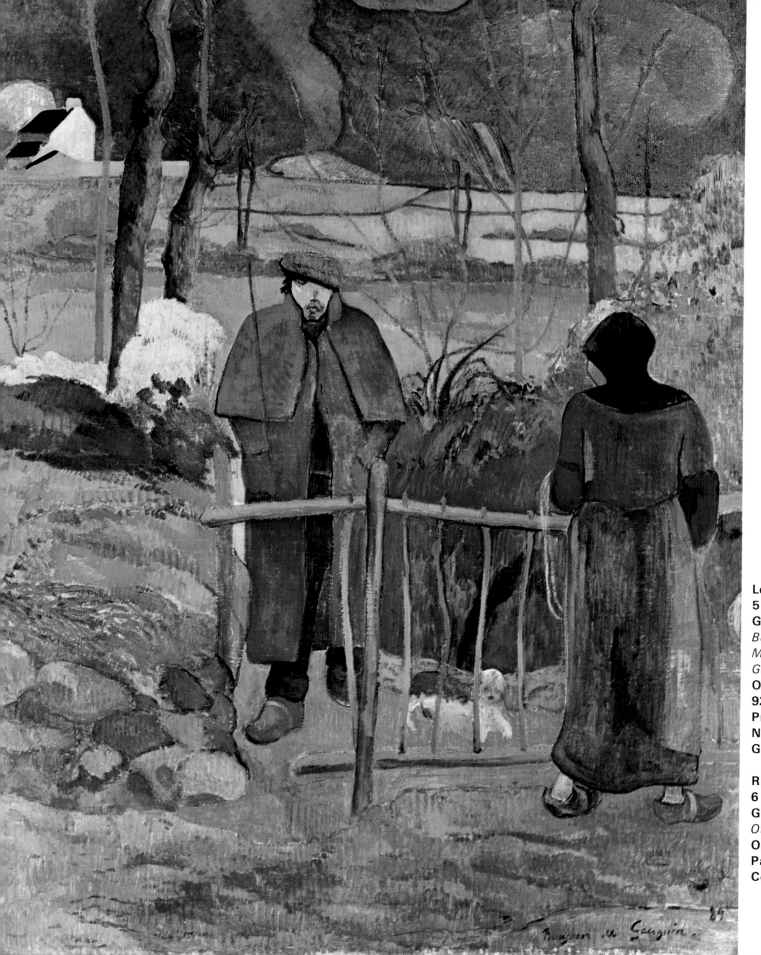

Bonjour M. Gauguin

Left:
5 Paul
Gauguin
*Bonjour
Monsieur
Gauguin*, **1889**
Oil on canvas,
92.5 × 74 cm
Prague,
National
Gallery

Right:
6 Paul
Gauguin
Otahi, **1893**
Oil on canvas
Paris, Private
Collection

38

Gauguin broke with Monet's or Pissarro's Impressionist style in his attempt to realize the direct opposition of colours, purity of line and broad self-contained expanses as composition elements in the picture. He uses dark outlines, in order to separate the individual colour forms from one another.

As the composition of *Bonjour Monsieur Gauguin* indicates, he is here not primarily concerned with the arrangement of a scene, in which the painter meets a peasant woman; this merely serves as a pretext for the organization of a colour pattern. Not only trees, gate, and horizon, but even the figures themselves are used to create a perfectly balanced pictorial composition. The artist uses this framework of objects to distribute alternately lighter and darker patches of colour, carpet-like over the surface of the picture, with different shades within the individually related green, blue, or reddish-brown colour forms—not so, however, that the brushstroke corresponds to the plastic qualities of the object portrayed, but two-dimensionally, in a parallel plane. At the same time, all external illumination is replaced by the natural luminosity of the colours.

The pictorial organization of a painting with the help of colour forms was Gauguin's central visual preoccupation. In *Otahi*, the physical form of the woman is virtually a decorative colour form. Gauguin gives particular significance to the emphasis of the silhouette: 'Pay attention to the silhouette of every object,' he wrote. 'One should always sense the plane and the wall—tapestries do not need perspective' (Hess, p.31). The point of his style is not, as one critic wrote on the occasion of the exhibition of Gauguin's pictures at the Munich Künstlerverein in 1904, 'to come as near as possible to nature', and thus to be simultaneously 'refined', 'subtle', and 'simple', but rather, in the words of the artist himself: 'If an artist wishes to produce a creative work, he must not imitate nature—he must take the elements of nature, and create a new element' (Buchheim, p.16).

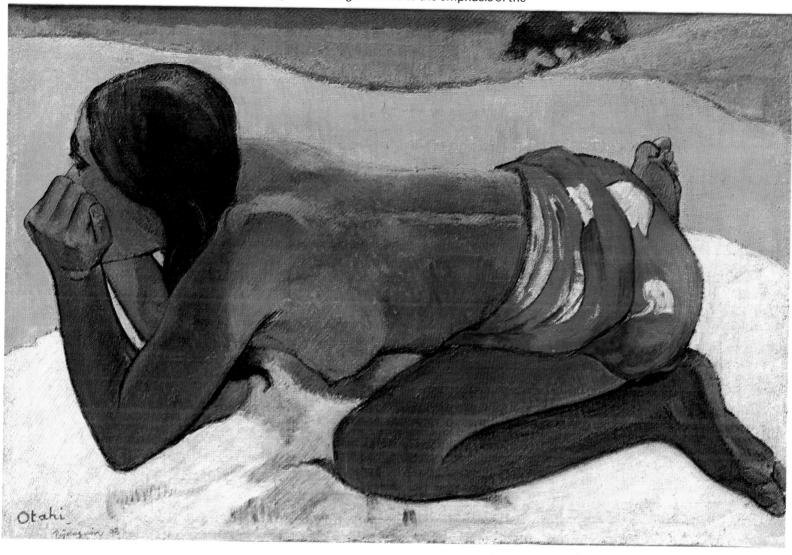

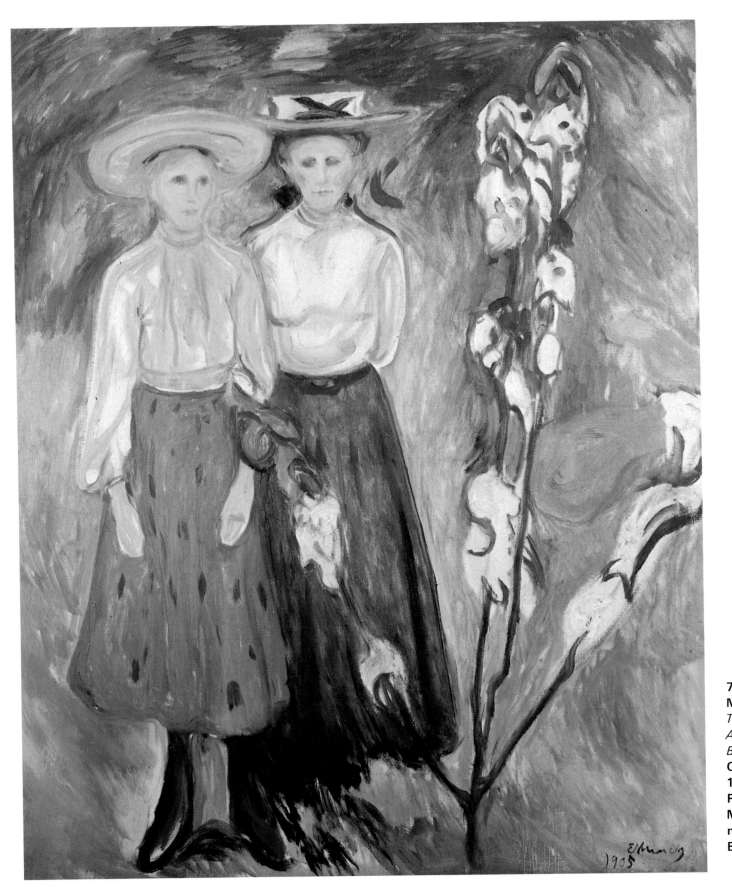

7 Edvard
Munch
*Two Girls by
Apple Trees in
Blossom,*1905
Oil on canvas,
130 × 110 cm
Rotterdam,
Museum Boy-
mans–van
Beuningen　40

Munch wanted, as he wrote in his diaries, to stop 'painting interiors and women knitting'. He wanted to get away from traditional themes in art. He was thus virtually obsessed with some themes, dealing with man poised between nature and tradition. Like the Scandinavian writers of the time, particularly Strindberg and Ibsen, he is concerned with the unmasking of the lie of life, to which end he employs psychological, symbolic, and partly mythological or allegorical means of portrayal. He achieves a synthesis of elements from Symbolism and *art nouveau*, which he imbues with an Expressionist power, and it is this that constitutes his importance as a forerunner of Expressionism.

In 1908, the Viennese architect Alfred Loos, believing the work of the artists of the Vienna Secession to be over-decorative, demanded: 'Depict for once the reality of birth and death, the cries of pain of a wounded son, the death rattle of a dying mother, the last thoughts of a daughter going to her death . . .' (Loos, p.240). Munch had done just that a whole two decades earlier, as a mere glance at his titles reveals—*The Sick Girl* (1885–6), *Death Struggle* (1896), *Death Chamber* (1894–5), *Dead Mother and Child* (1899), and so on.

For Winckelmann and Goethe, the portrayal of man screaming out was reprehensible, and it was, on the contrary, the artist's duty 'to restrain and moderate . . . the passionate outbursts of human nature'. Munch, on the other hand, made exactly this the subject of The Scream, representing it not scenically, but by making the scream (or, in other pictures, death, or fear) visible, without at the same time making it specific to any one social group. This he achieves above all through the de-individualization of physiognomical details, and the generalization of the external appearance of the figures. Thus, in the example, it is not the individual figure of a screaming man which is portrayed. The figure itself is reduced to minimum of features sufficient to indicate a person: a skull-like head, with mouth wrenched wide open, its hands pressed to its head, and its body merely suggested. Behind

it, a bridge railing runs diagonally across the picture from lower right to upper left (the motif recurs frequently in Munch's pictures, lithographs and woodcuts) and there is the suggestion of a maritime landscape. The style of execution, where figure and land-

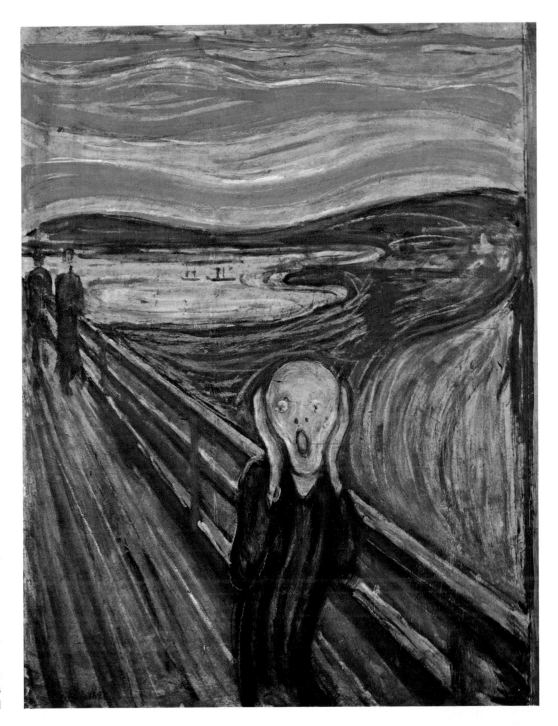

8 Edvard Munch
The Scream, 1893
Oil on cardboard, 84 × 67 cm
Oslo, National Gallery

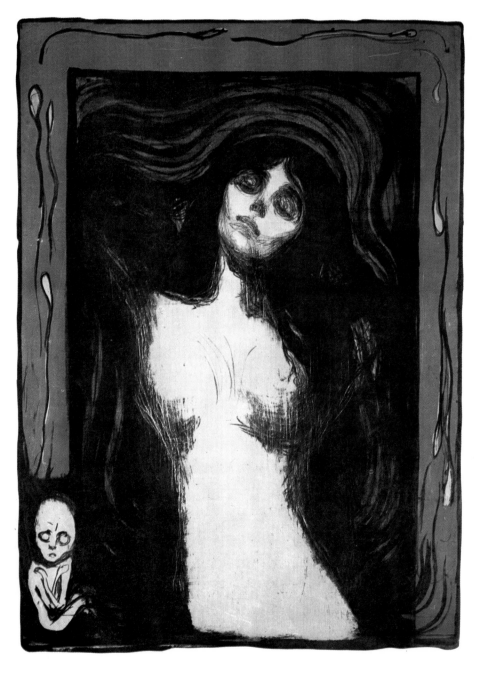

scape are equally determined by the rhythmical movement of line and colour, combines figure and landscape in such a way that on the basis of this pictorial organization both are united, independent of their different subject matter. On some copies of the 1895 lithograph corresponding to this painting, Munch wrote the sentence: 'I feel the scream of nature.'

In looking at the line of this picture, one should notice the similarities with the work of Toulouse-Lautrec (1864-1901), for instance his famous pastel *Loie Fuller* (1892–3). Munch had got to know Lautrec's work during his visits to Paris.

The portrayal of man's psychic condition is particularly prominent in Munch's work. He did not paint any still-lifes, and did not choose any subjects taken from Christian tradition.

Conception, like many of his pictures, exists in several versions—he made a copy for himself of every picture which he sold, often making minor changes at the same time. A young woman is portrayed here, whose body stands out in sharp relief against the darkness of the background. In the bottom left-hand corner of the picture is a huddled embryo. Around the edge of the picture, sperm are seen swimming against the red-brown border, around the waves of the dark background. The figure appears statuesque in its immobility, as in *Two Girls by Apple Trees in Blossom*. Movement occurs particularly in the flowing fringe, bounding the forms. Their place in the composition especially interested the artist: 'This much at any rate I have in common with Michelangelo and Rembrandt,' he said, 'that line—the rising and falling of line—interests me more than colour' (Stenersen, p.139). But it is precisely the rising and falling of line in Munch's graphic work which makes the

9 Edvard Munch
Conception, **1895–1902**
Colour lithograph, 60.5 × 44.2 cm 42

figures appear as naturally grown shapes; the movement of line produced with colour and brushstroke is particularly important for the style of these pictures.

As a result of Munch's strong interest in line, his graphic output is considerably larger than his painting: although at the beginning of his career he was primarily a painter, in his later years he turned to graphics more and more, and only occasionally painted Norwegian landscapes and portraits. His pioneering explorations were essentially in graphic art.

10 Edvard Munch
*Winter Landscape in Kragerö,***1925**
Oil on canvas, 136 × 151 cm
Zürich, Kunsthaus

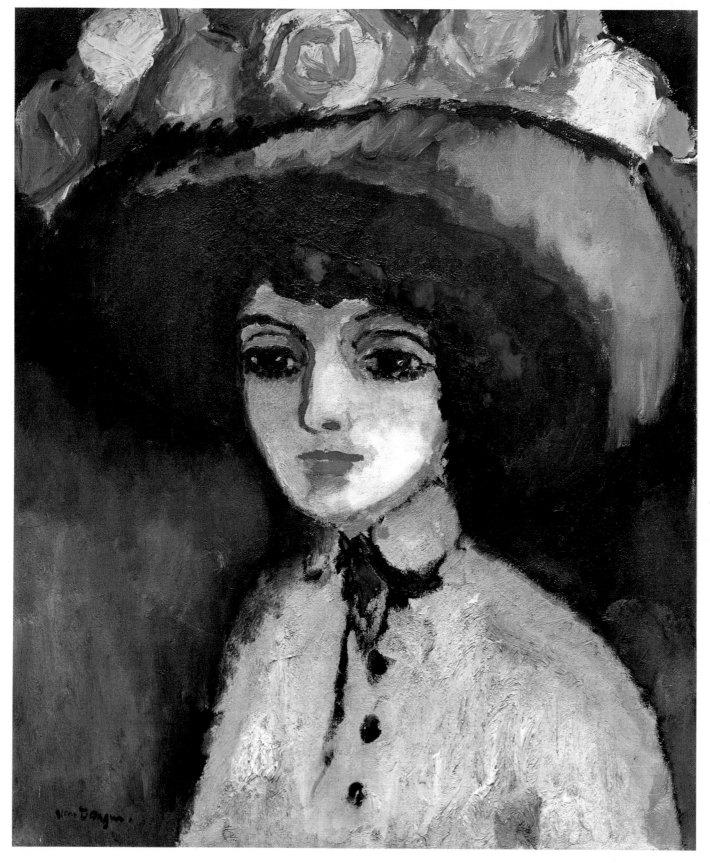

11 Kees van Dongen
The Parisian Lady from Montmartre,
1910
Oil on canvas,
64 × 53 cm
Le Havre, Musées du Havre

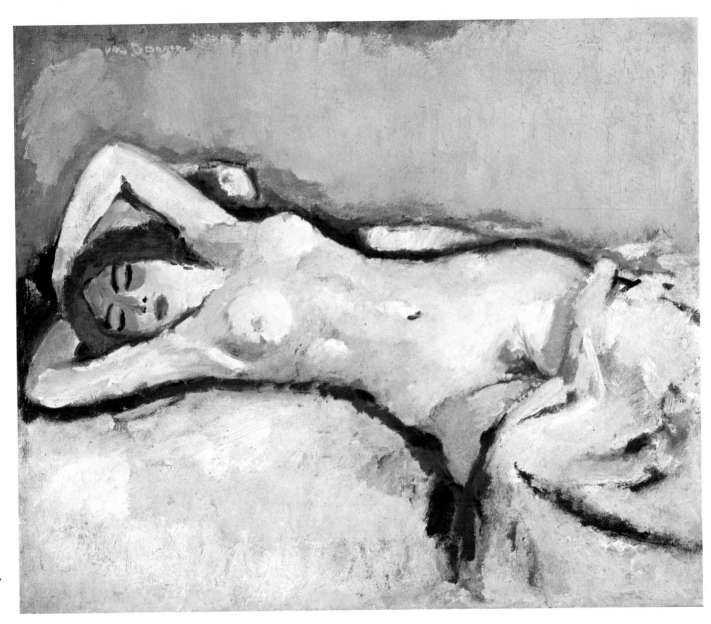

12 Kees van Dongen
Mika—Nude on the Sofa, **1908**
Oil on canvas, Private Collection

The Dutch painter **van Dongen**, whose work was at first rather heavy-handed and not especially interesting, twenty years later was the most sought-after artist and portrait painter in Paris. More than any other of the Fauves (whom he joined enthusiastically in 1906), his *oeuvre* consists predominantly of nudes.

The example illustrated here shows a naked girl with her arms folded behind her head, turned towards the observer, against a light-grey background, the silhouette emphasized with a broad black line, and the body also painted in soft greyish-white. The picture is an example of the combination and opposition of dull colours (grey, white, black) and sparingly used light colours (light blue, light blue-green, light yellowish-green, light yellow). The brown parts, lightened up to the red of the girl's lips, create the transition between the subdued colour of the bed, sheet and figure, and the ochre background. At the same time, the illuminated parts of the figure are characterized by bright colours, so that external illumination appears as the intrinsic luminous quality of the painting.

Although van Dongen was not deliberately flattering in his portraits, he was nevertheless prepared to compromise, and his painting constantly verges on mere competence. But in connection with the development of Expressionism, it is his pictorial concept which is important, as when, in his emphasis on plane and colour, he organizes the colours in such a way that they make visible the material quality of the depicted objects. The delicate use of colour releases the tactile character of the figure, revealing to the observer the connection between sight and touch, without creating the kind of realistic situation where a bird might feel tempted to eat painted fruits.

13 Vincent van Gogh
Self-portrait with Pipe and Straw Hat, **1888**
Oil on canvas, 42 × 31 cm
Amsterdam, Rijksmuseum Vincent van Gogh

In the 1880s, **van Gogh** was both biographically and artistically an exceptional phenomenon, combining absolute artistic commitment with the utmost humanity. Every action or fragment of an action was based on commitment, and he did not allow any compromise with contemporary taste or the inherited preconceptions of the observer.

Although his connection with French Impressionism should not be ignored, van Gogh was always an independent painter, and his work always retained an autodidactic originality. Whereas the Impressionists emphasized neither the outlines nor the intrinsic forms of objects, in order to show the colour unity of things, for van Gogh the drawing was the framework of the picture, in terms of both outline and internal drawing. He attempted to create a unity between painting and drawing, where colour is indeed unambiguosly dominant, but where the graphic quality is as strong as if colour were itself a graphic medium, as can be seen by the comparison of a sketch and a monochrome reproduction of *Cypresses* (1889), or *Washerwomen on the Canal* (1888). 'Few people regard drawing and colour as one,' said van Gogh, 'they draw with everything except colour. I am beginning to treat this with the same ease as writing' (Hess, p.27).

Objects are differentiated and defined, and the picture is composed and built up by the use of colour. The painter more and more replaces dabs of colour in all directions with a directed brushstroke, proceeding naturally from the Pointillist technique developed by the Impressionists. The interrelation of line and colour serves to increase the optical

value of colour. The picture is thus so organized that it has its own colour scale, for instance in *Sunrise at Saint-Rémy*, with its constant juxtaposition and merging of greens, blues, yellows and browns, so that the landscape does not appear prettified in any way, but as a completely pure colour phenomenon, enabling the observer to look at the landscape from a completely new point of view.

The farmer works the land in order to harvest its fruits and to earn his scanty living in close dependence on the soil. The painter, on the other hand, works at the colours of the landscape in such a way as to liberate the ordinary everyday view, for both work *and*

14 Vincent van Gogh
Landscape at Auvers in the Rain, **1890**
Oil on canvas, 72 × 90 cm
Leningrad, Hermitage

15 Vincent van Gogh
Sunrise at Saint-Rémy
Oil on canvas, 71 × 80.5 cm
Nice, Private Collection

holiday, hardship *and* breadth, the heat of the sun *and* dispersed light.

'Colour expresses something in itself. We retain the beauty of the colours of nature not by literal imitation, but by creating them anew, with an equivalent colour scale, which does not have to be the same as the original scale at all ... One begins with fruitless drudgery, following nature, and everything goes against the grain; one finishes by calmly creating from one's own palette, and nature follows harmoniously out of it. But these two opposites cannot exist without one another' (Hess, pp. 24f.).

Through the style, which equally activates both colour and drawing, the manner of execution always becomes part of the theme, and the visual quality of the picture lies in the tension of the artistic action. The interweaving of line and colour erases the differences in the subject matter of the objects, and merges them with one another in subordination to the overall conception, to form what van Gogh called 'a little colour music'.

48

Vlaminck was, in his life and art, a Fauve. He was versatile: painter, writer, musician, farmer, racing driver. He is said never to have visited the Louvre. He rebelled against everything, not just against schools, academies, and affected and aesthetic works of art. He painted in bright colours and in a spontaneous style, according to the impulse of the moment. His palette was characterized by rich tones, especially red, green, blue, and yellow. He aimed at a vigorous and as far as possible unconditioned, instinctive kind of painting without any intellectual refinement, and described his ideas thus: 'Theories have the same use in art as prescriptions in medicine: in order to believe in them, you have to be ill. Knowledge kills instinct. One doesn't just do painting, one does one's *own* painting. My aim is to rediscover the impulses submerged in the depths of the unconscious, which superficial life and conventions have concealed from us. I still regard things with the eyes of a child . . . I have composed from instinct, and I paint with one single idea which

16 Maurice de Vlaminck
Sailing Boat, **1906**
Oil on canvas, 50 × 65 cm
Marseilles, Augustin Termin Collection

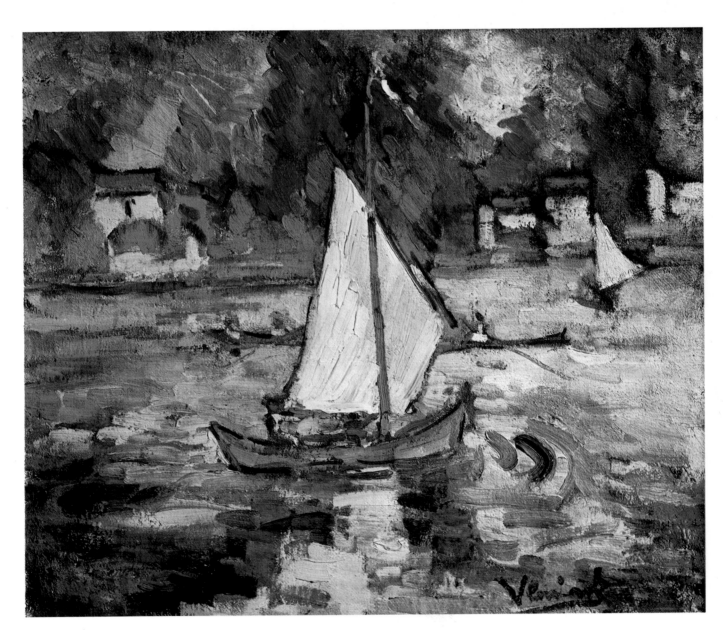

49

17 Maurice de Vlaminck
*Still-life, c.*1907
Oil on canvas, 60 × 73 cm
Saint Tropez, Musée de l'Annonciade

for me excuses everything: saying what I mean. I stammer out my ideas . . . I have had no preconceived ideas. Being a painter is not a profession, any more than being an anarchist, a lover, a runner, a dreamer, or a boxer . . .

'My passion urged me on to all kinds of revolt against the conventional in painting. I wanted a revolution, in morals, in daily life; I wanted to depict unrestrained nature, and to liberate it from the old theories and from Classicism. I set myself no other goal than this: by new means to express the profound relationships which bound me to the earth. I was a sensitive, impetuous barbarian. Not committed to any method, I conveyed not an artistic, but a human truth' (Hess, p.43).

In his attempt to get rid of all conventional representational methods, Vlaminck ended by making the unmethodical into the only method; but after 1915 he began to slip into traditional realism, and his painting became lifeless and unoriginal.

The Brücke

Heckel

Kirchner

Mueller

Nolde

Pechstein

Schmidt-Rottluff

Erich Heckel
Reading, **1914**
Woodcut, 30 × 20 cm

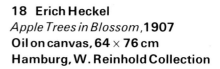

18 Erich Heckel
Apple Trees in Blossom, **1907**
Oil on canvas, 64 × 76 cm
Hamburg, W. Reinhold Collection

19 Erich Heckel
Hanging Nets (Stralsund), **1912**
Oil on canvas, 68 × 80 cm
Stuttgart, Private Collection

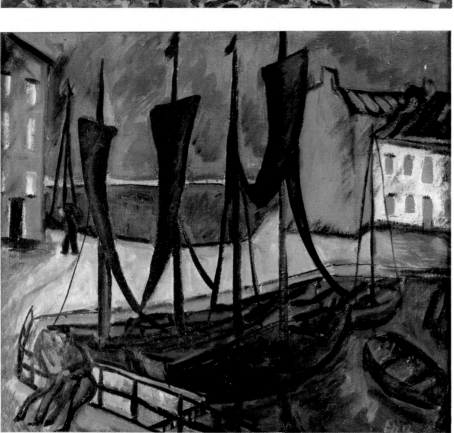

Pre-Expressionist painting, moving away from Naturalism and Impressionism, shows one basic feature: in their attempts to regain the draughtsman's framework, the artists achieved the merging of drawing and colour, characterized by brushstroke, line, and form. Clear, unbroken colour expanses replaced the Impressionists' diffuse and fragmentary pointillist use of colour. This is the most important feature of the new pictorial organization. In addition came the Symbolist change of subject towards the portrayal of psychic conditions and subjective experiences. Through the discovery of pure colour and colour for its own sake, its material quality became explicitly involved in the pictorial conception, thus achieving a materiality which now represented the materiality of the portrayed objects as a whole. In artistic commitment, a critical drive was dominant: on the one hand, the confrontation with traditional art and its conventions, and, on the other, the criticism in visual terms of the triteness of everyday life and its apparent perfection, deadened and made monotonous through repressive law and order.

For the Expressionists, these aspects became liberating factors which determined their art. They used criticism as an essential part of daily life, and consciously turned to the primeval quality of the simple and unsophisticated life, as opposed to the sated complacency and spoonfed quality of the visual culture at the beginning of the twentieth

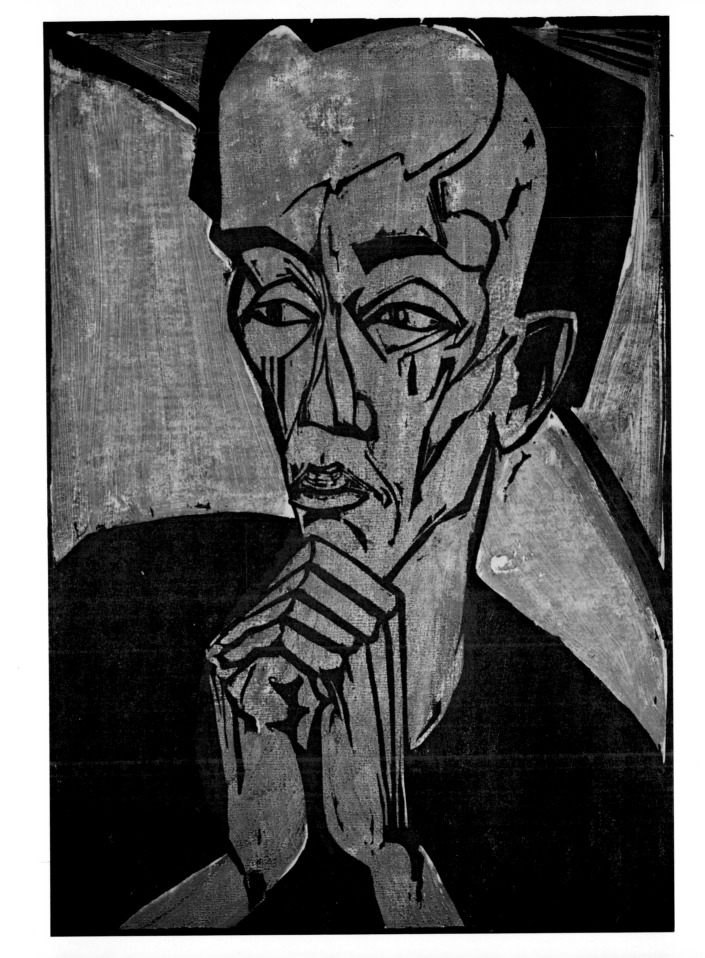

20 Erich Heckel
Male Portrait, **1919**
Coloured woodcut,
53 **46 × 33 cm**

century, exemplified by the gently *risqué* or titillating richly draped photographic nude, which had recently became a collector's object. They turned against the lack of criticism, a lack which threatened to deaden into total indifference. They aimed not for the merely provocative but for the 'sensation' of the self-evident, by portraying and emphasizing the clearly and quickly changing ordinary life (with the growth of industrialization and urban development) in theme, composition, and pictorial organization. They thus demanded from the observer an actively argumentative stance, instead of mere contemplative passivity. This was necessary because the Expressionist artist no longer created his works with primary reference to the visible world, but increasingly started from the material appropriate to painting, from which he selected and applied the artistic means necessary in each particular case.

21 Erich Heckel
Bathers, **1914**
Oil on canvas, 83 × 96.5 cm
Bonn, Städtische Kunstsammlungen

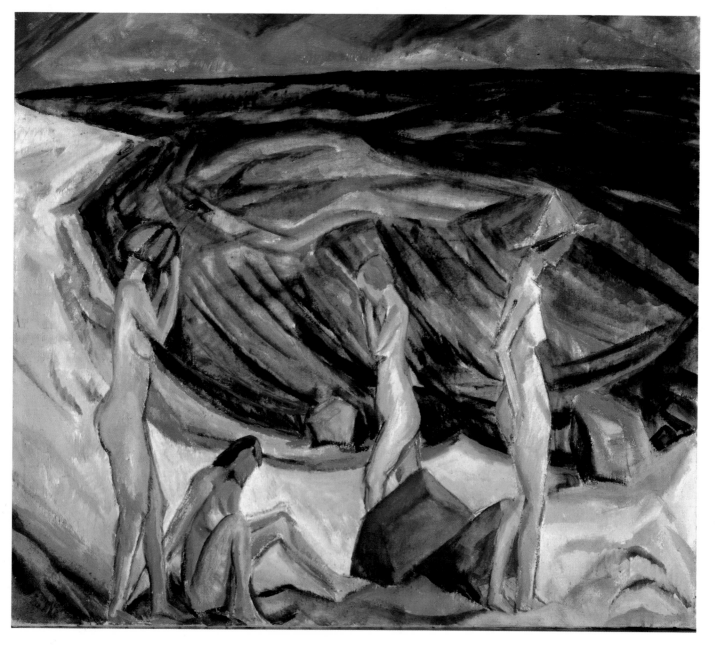

Heckel was the most subtle and the most cautious of the Brücke artists. Selflessly devoted to the cause of art, he was the one most affected by the break-up of the group in 1913.

The pictures illustrated here document the essential stages of the development of his painting from monumental Impressionism in *Apple Trees in Blossom* up to the Cubist-influenced *Glassy Day*. For the Nazis, Heckel was the 'classic decadent'.

His pictures show us the de-mystification of virtuosity, and of the prevailing academicism, which merely sought to dazzle, At the same time, they attack the aestheticism which seeks its fulfilment in purely charming work. Their often austere and harsh colouring, and their inherently subdued quality also do something to reinforce the impression of the spiritual. In its simplicity, his work at the same time suggests an ungainly kind of artistic activity, working 'against the grain', concerned not least with self-examination. The approximation to a bird's-eye view in some of the paintings means that the artist becomes an invisible character in the action, making the observer see the picture from outside, from a distance and without any preconceived ideas, in order to inflate him to a less constricted visual experience.

In *Glassy Day*, the motif of reflection, particularly important in Heckel's work, determines the splintered composition. The female nude projects from the bottom left of the picture towards the Cubist-sculptural forms. Through multiple repetition, and the intense, crystalline formation, the portrayal of the bathing woman takes on, in pose and bearing, an extraordinarily natural, self-evident quality. The physical forms are equivalent to the landscape forms, and through the apparently random position of the body any kind of hierarchy is negated (though without any naïve levelling). Landscape and figurative elements are of equivalent importance and character in the pictorial composition. This equivalence of the different pictorial elements offers a new way of looking at things, which can also be seen with regard to their materiality. The artist has set himself the task of giving the objects a new sense of order through 'objective humanity'. The observer is thus faced with a representation of reality which forces him, if he wants to understand the picture at all, to re-examine his accustomed ways of perceiving things, so that the picture becomes for him a choice of alternatives, by questioning in every respect the preconceived opinions which have determined his perceptions.

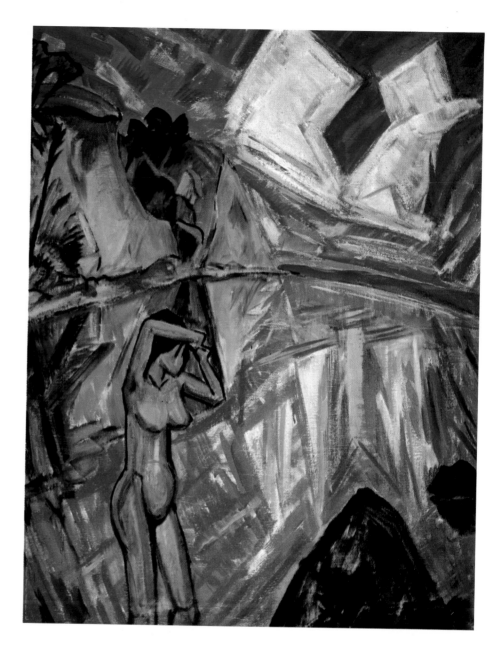

22 Erich Heckel
Glassy Day (Bathing Woman by the Sea),
1913
Oil on canvas, 120 × 96 cm
Berlin, M. Kruss Collection

23 Ernst Ludwig Kirchner
Recumbent Blue Nude with Straw Hat,
c. **1908–9**
Oil on cardboard, 68 × 72 cm
Offenburg, F. Burda Collection

The first thing that probably strikes the observer of **Kirchner's** paintings is their flat and sketch-like quality, the carpet-like structure especially typical of his Swiss period, which is distinguished by juxtaposed and interlocking (but not usually overlapping) colours, and the often hard brightness of the colours and harsh dissonances. Kirchner developed similar techniques of composition for writing, defined by himself in 1920 by the word 'hieroglyph': 'The hieroglyph as the expression of reality experienced, probed to its source, has nothing to do with stylization, it is recreated for each object, and each object is something different and new each time, if it recurs in several images' (Hess, p.48).

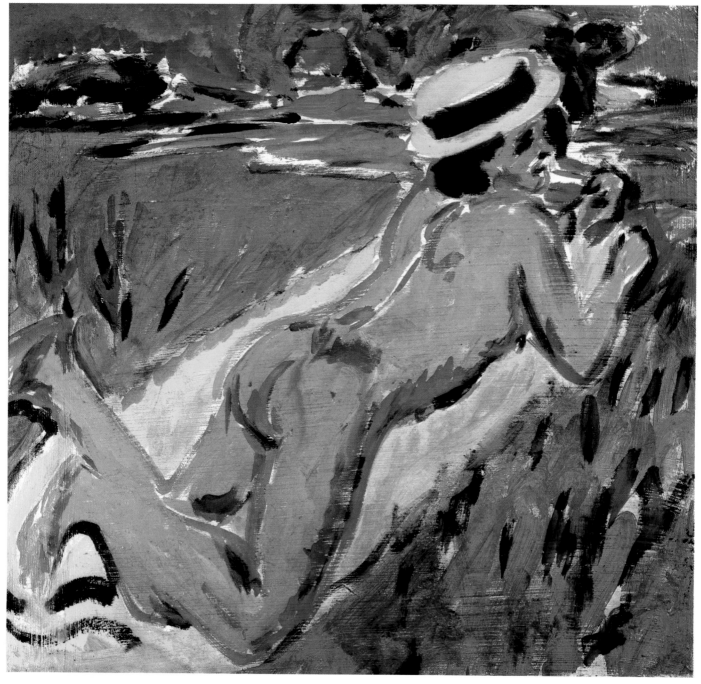

Kirchner depicted the immediate environment with which he came into contact—working-class children in Dresden, girls from sleazy nightclubs, Berlin *demimondaines*, shepherds and farmers around Davos, and, again and again, the Davos landscape. His own daily life was for him the pivotal point of his art—and daily life included his own pictures, used as decoration, as well as other objects like chairs, bed, bathtub, the binding of his diary, and so on. The most important thing for Kirchner was to create as far as possible not only the pictures, but everything surrounding them, too. In this sense, he saw creation, portrayal and symbolization as the tasks dominating his whole life.

Inasmuch as order was for him always an order created by himself, he no longer depicted the objects of the visible world as a painter and draughtsman—they were for him mere pretexts for his artistic activity. 'It is thus wrong to judge my pictures by the yardstick of lifelike accuracy,' he wrote, 'for they are not images of specific objects or beings, but independent organisms of lines, planes, and colours, which only include natural forms to the extent to which they are necessary as a key to understanding' (Hess, p.47). He expressed a similar idea in his diary in 1926: 'If one applies the natural form as a yardstick or explanation, one will never achieve anything. My work is not any kind of copying or reproduction, its relation to nature is like that of the graphs on an apparatus for registering power output—or, better, the machine to which the measuring apparatus is attached. There are still few people who can understand the purely graphic image' (*Davoser Tagebuch*, p.134).

The observer must thus learn to understand the picture on the basis of the combination of its artistic means used as composition elements. Blue as the colour of a female nude, in combination with, for instance, green, violet, and red, has a significance beyond the mere fact that one does not normally portray the human body as blue. Thus, within the picture, colour overlaps or merges separate planes. Our eye is drawn to the outlines, and uses these, with the help of

what the picture itself shows, for orientation. Such a picture always gives, in addition to its theme, hints on how to see and interpret it, not only where it depicts natural forms as a 'key to understanding'. In the area between natural form and hints on interpretation, the hieroglyphic pattern of the picture can be discerned, inasmuch as the 'written signs' are developed individually for every painting.

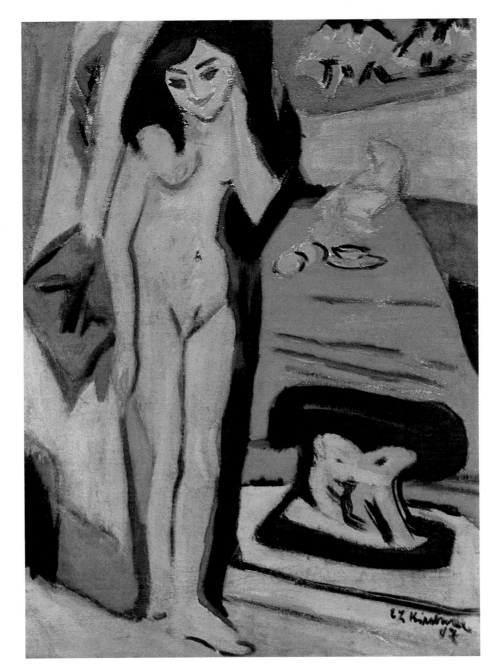

24 Ernst Ludwig Kirchner
Naked in a Room, Fränzi, **1910**
Oil on canvas, 120 × 90 cm
Amsterdam, Stedelijk Museum

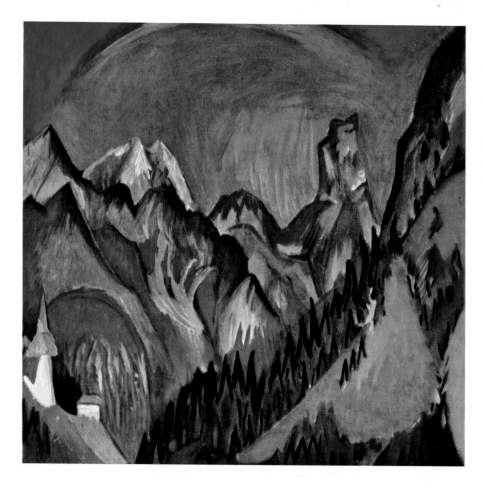

25 Ernst Ludwig Kirchner
Tinsenhorn, **1919–20**
Oil on canvas, 119 × 119 cm
Cologne, Private Collection

26 Ernst Ludwig Kirchner
Mountain Landscape
Stuttgart, Private collection

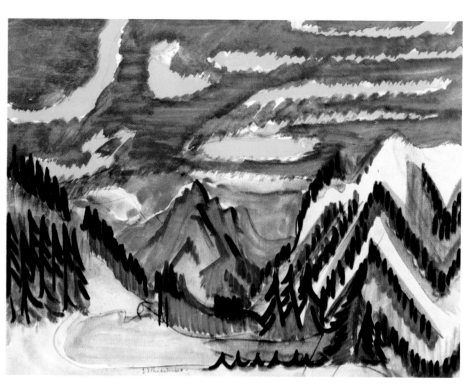

Mueller, considerably older than the founders of the Brücke, was also more tied to tradition. He was particularly close to Heckel, and was perhaps the most Symbolist of the Brücke artists. Although his technique and artistic means did not change very much during his own development, he did produce successful (if sometimes over-romanticized) pictures of the simple life, especially of gypsies. These pictures were of ever-increasing intensity, and in them he cultivated the depiction of pairs of figures, particularly the period of transition, between the womanly girl and the girlish woman. He created a female type which in its unity with its natural environment embodied the conflict between irritating inactivity and a satisfying existence with few needs.

In his best pictures, Mueller succeeded in showing how the figures represented understand nothing of their own condition, but simply live it out, and it is this that gives his pictures their primeval paradisiac quality. He was somewhat influenced by the very thin female figures of Lehmbruck or Modigliani, and also by Egyptian art.

The angularity of outline, always contrasted with rounded forms—head, shoulders, hips, breasts—is continued in the tree trunks and forked branches (often cut off by the edge of the picture), and ensures tight composition. The binding oils in the paint, dissolved in turpentine, and often replaced by distemper emulsions, create a dull pigment which on unprepared jute or sackcloth (Mueller especially liked using old sugar sacks) is particularly effective, varying from an almost chalky stroke to a pastel gleam within a subdued but radiant overall colour. This technique, developed by him to perfection, demanded that everything be painted confidently with a single stroke, since any later correction would always have remained visible.

The comparatively traditional quality of his paintings can be judged by the fact that a passively contemplative attitude is sufficient to understand his art.

27 Otto Mueller
Gypsy Girls with Cat, c. **1927**
Oil on canvas, 144 × 109 cm
Cologne, Wallraf-Richartz Museum

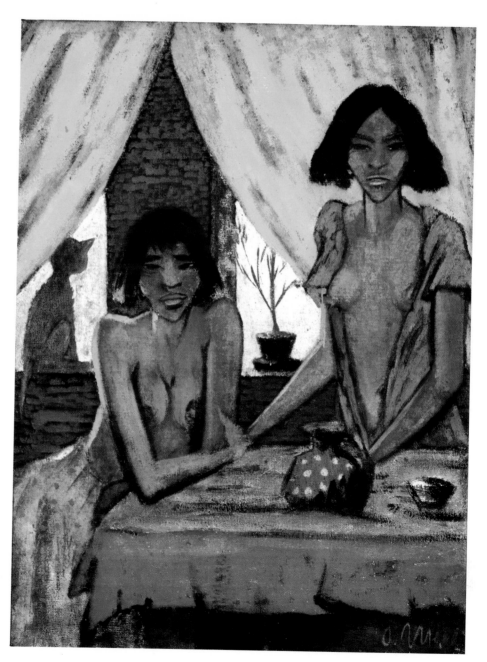

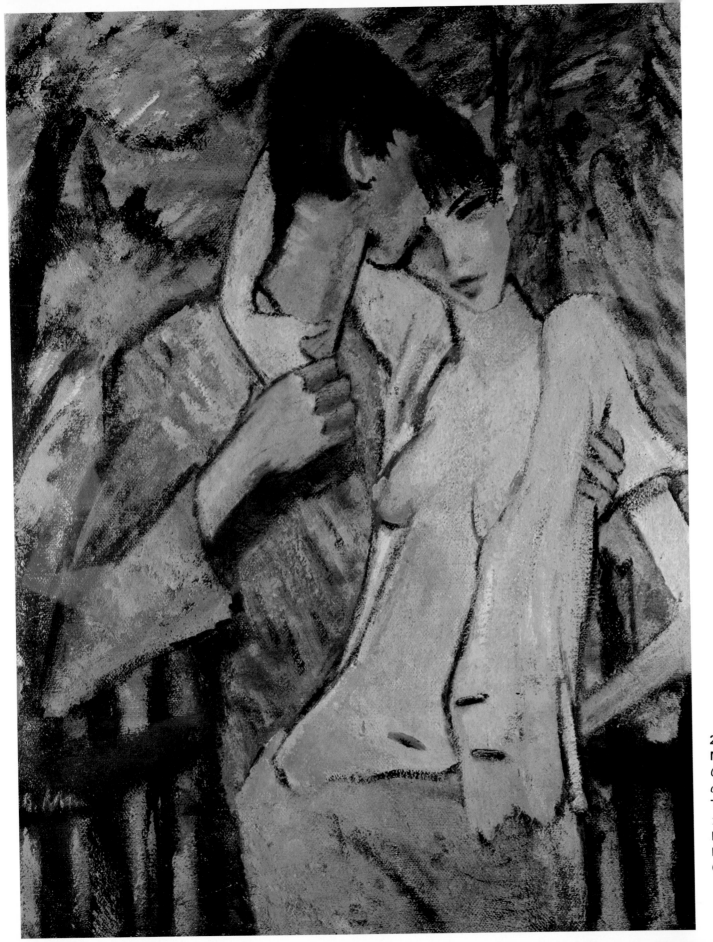

28 Otto
Mueller
Gypsy Couple,
*c.*1922
Tempera, 106
×80 cm
Hamburg,
Private
Collection

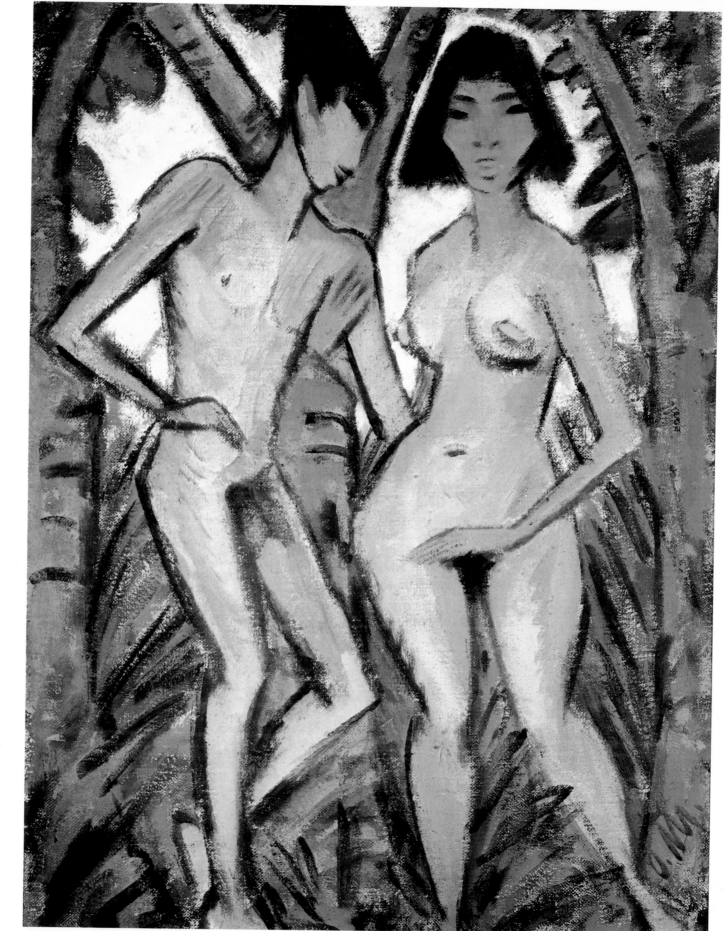

29 Otto Mueller
Adam and Eve,
*c.*1922
Tempera on
canvas, 121 ×
90.5 cm
Frankfurt,
Städelsches
Kunst
61 institut

30 Emil Nolde
Mermaid, 1924
Oil on canvas, 86.5 × 100.5 cm
Seebüll, Ada and Emil Nolde Foundation

Emil **Nolde** (born Emil Hansen) was shy and of a solitary disposition, which soon alienated him from all groups. In and with colour he depicted everything from the great rhythms of the elements to the waving of the flowers. His figure compositions, too, depict movement, and introduce sequences of individual motions into the picture. His paintings convey not the static quality of a gesture or a scene, but the dynamics of a sequence of actions like dance (Nolde's particular interest in dance dates back to his aquaintance with the great Mary Wigman). Nolde himself commented: 'I very much want my work to grow out of its material' (Hess, p.45). This meant firstly that the artist was no longer tied to fixed artistic rules, but was free to explore his materials, and secondly that, of the materials of painting in its widest sense, colour took undoubted pride of place. 'In painting,' he wrote, 'I always wanted the colours to be worked out through me on the canvas with the same natural logic as natural formations, the for-

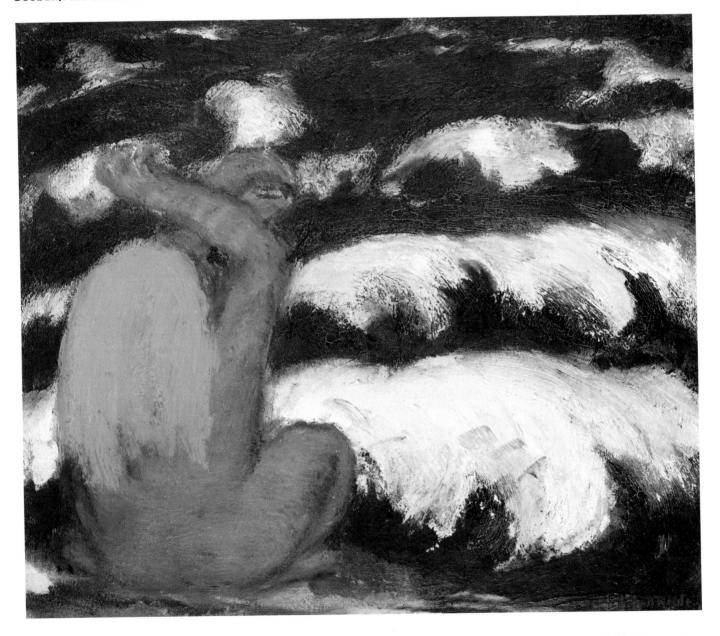

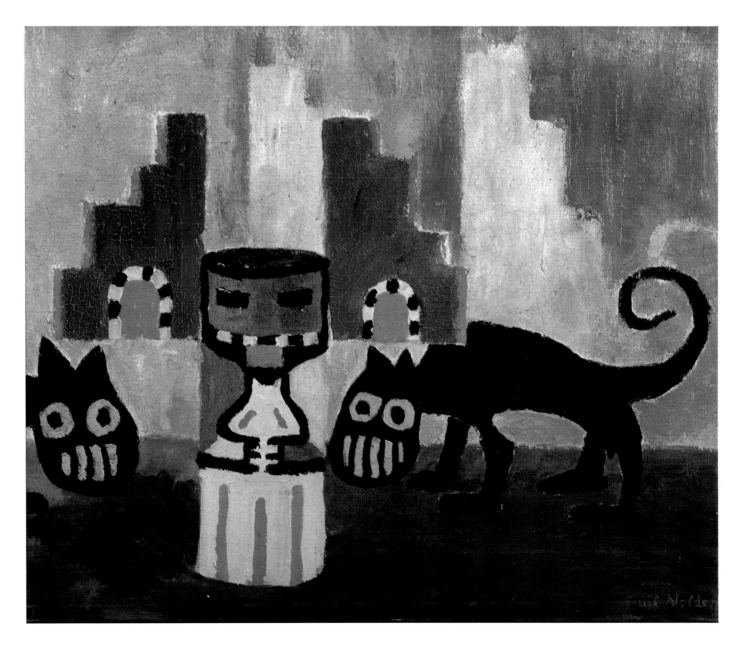

mation of ore and crystals, the growth of moss and algae, or the developing and blossoming of a flower in the sunlight' (Hess, p.45).

The starting point for the most varied use of colour was essentially a composition without any outlines, so that colour outline as colour mass and as a whirl of colour has to create for itself its own limits and structuring. He especially succeeded in this aim through the emphasis on the substantial and plastic quality of the colour material, so that the pictures seem to be made up of a mass of whirling, gushing colour. This broadside of colour, often rich in nuances, has a virtually hypnotic power. Nolde wrote: 'I would like my pictures to be more than some nice accidental entertainment—I would like them to be uplifting and moving, and to give the spectator a full awareness of life and human existence' (Hess, p.45).

Using colour in previously unknown ways, where colour was controlled only by artistic activity before the canvas, and every

31 Emil Nolde
Exotic Figures, **1911**
Oil on canvas, 65.5 × 78 cm
Seebüll, Ada and Emil Nolde Foundation

63

framework represented an unwarranted restriction, Nolde succeeded in his representation, for example, of sea and clouds, in creating new patterns of experience, which could then in turn—in, say, photographing such subjects—lead to a 'Noldean' way of looking at these things.

He began his career in the boisterous manner of monumental Impressionism. His subjects included his home area, seascapes and garden pictures, and fantastic and grotesque figures, as well as the important religious compositions that he produced after 1909, including a nine-part altar painting with scenes from the life of Christ, and the triptych of Mary of Egypt. *Pentecost*, too, rejected by the jury of the Berlin Secession in 1910, belongs in this category. In addition, he created several subjective myths of everyday life, as, for example, *The Big Gardener* (1940). Masks, primitive plastic works, and exotic motifs of various kinds occur in his still-lifes.

Nolde constantly returned to the most important thing in his painting, more important than any question of subject matter: 'Colours, the material of the painter: colours in their own life, weeping and laughing, dream and happiness, hot and holy, like love songs and eroticism, like hymns and magnificent chorales! Colours are vibrant like the tinkling of silver bells and the peal of bronze, heralding happiness, passion and love, soul, blood, and death' (Hess, p.46).

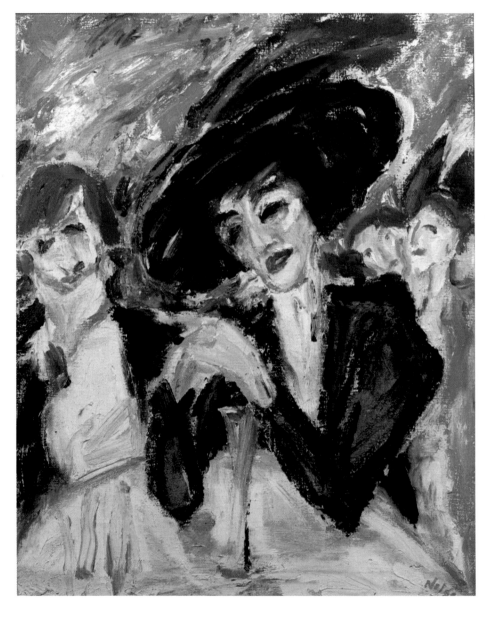

32 Emil Nolde
At the Wine Table, **1911**
Oil on canvas, 88 × 73.2 cm
Seebüll, Ada and Emil Nolde Foundation 64

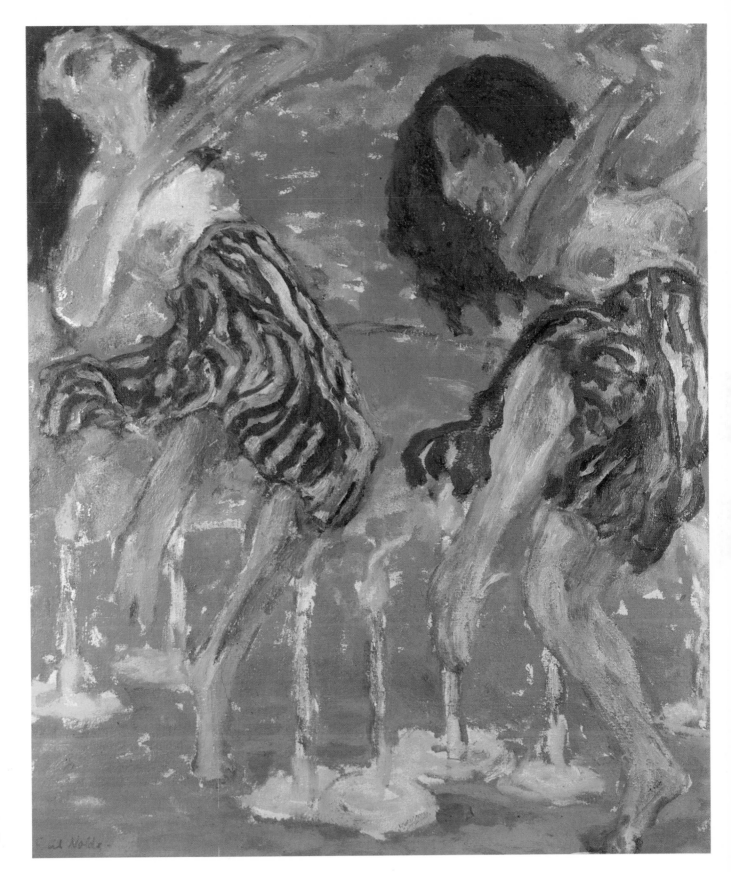

33 Emil Nolde
Candle Dancers, 1912
Oil on canvas,
100 × 86.5 cm
Seebüll, Ada and Emil
65 Nolde Foundation

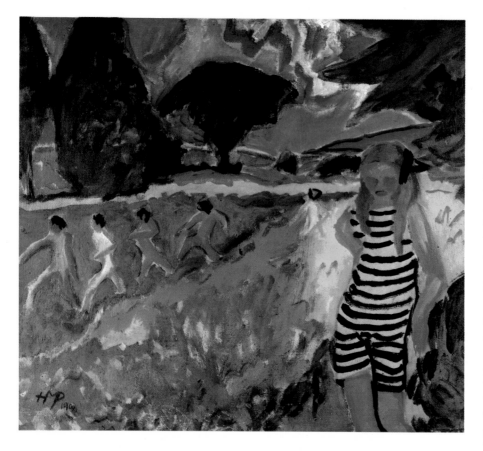

Pechstein's memoirs give an insight into the daily preoccupations of the artist. 'In summer 1906, the International Exhibition of Perspective Art was organized in Dresden. In the spring I had seen a bed of fiery red tulips in the garden of the keep. It intoxicated me like the yellow sunflowers of Goppeln, or in the same way that in the Ethnological Museum I had been filled with longing by the carvings on roofbeams and crossbeams from the Palau Islands in the Pacific Ocean, as though I already sensed this distant tropical world. The tulip-bed by the keep I "hurled" onto the canvas. It no longer exists. But for my eyes the red glow was a fanfare.

'For the Saxon Pavilion of the exhibition, I had been commissioned by the architects Lossow and Max Hans Kühne to produce a ceiling painting and an altar painting, and also some smaller ceiling paintings for Professor Wilhelm Kreis. In the large ceiling painting, I ranged my tulips. But when I went there before the opening, I saw to my horror that the burning red had been toned down with splashes of grey paint, made more sober and more acceptable to ordinary taste. The scaffolding had vanished; I stood powerless below, and could no longer climb up to my work again. I gave vent to my fury. Suddenly there was someone beside me, seconding me in my torrent of abuse. It was Erich Heckel, then still studying with Kreis. We rejoiced to find an identical urge for liberation, for an art surging forward and unrestricted by conventions' (Pechstein, pp.22f.).

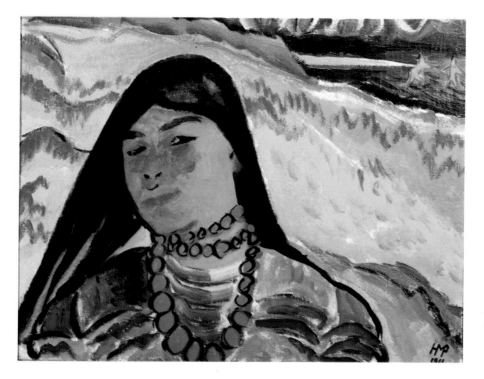

34 Max Pechstein
Girl in Black and Yellow, **1909**
Oil on canvas, 68 × 78 cm
Berlin, M. Pechstein Collection

35 Max Pechstein
On the River Bank, **1911**
Oil on canvas, 50 × 65 cm
Berlin, Neue Nationalgalerie

If on the basis of a comparison of **Schmidt-Rottluff's** works we try to determine his specific artistic aims, we find ourselves dealing with two phases. In the first, the painter tries to discover how far characteristics of objects in the visible world can be ignored in the artistic representation without eliminating the existence of the object itself, since the object is after all necessary as a key to the understanding of

36 Karl Schmidt-Rottluf
Landscape in Dangast, **1910**
Oil on canvas, 76 × 84 cm
Amsterdam, Stedelijk Museum

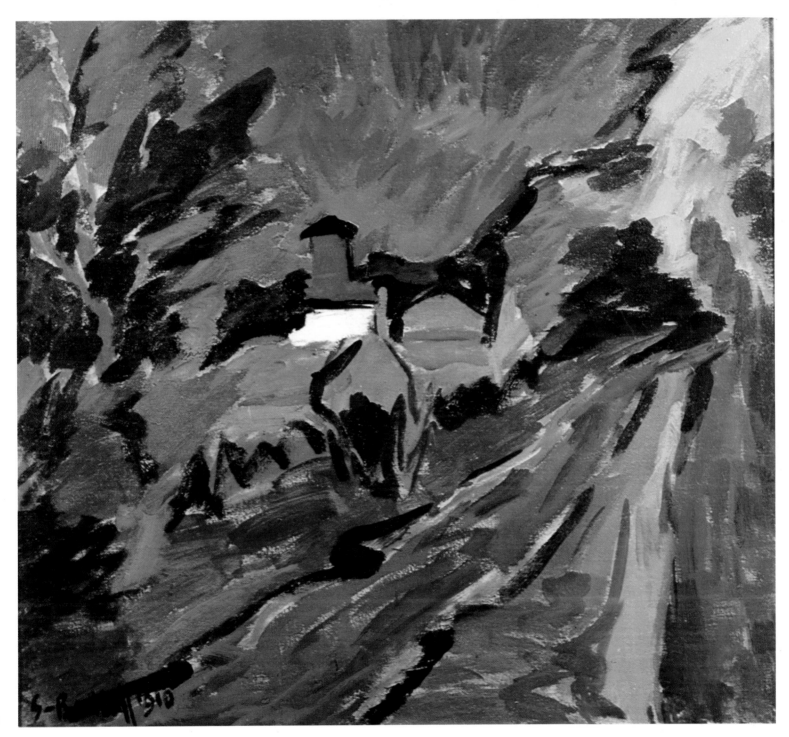

the picture. Schmidt-Rottluff found that he could entirely ignore the individual character of the depicted objects, and could instead create closed expanses and areas of colour, in which the colour application varies according to the brushstroke technique, and lacks any particular direction. By means of the relation between colours, he thus strengthens the whole composition. In addition, he can ignore actual landscape motifs and invent motifs freely according to his pictorial interests. Unlike Kirchner, Schmidt-Rottluff retained a perspective-dependent construction—as in the diagonal composition of *Landscape in Dangast*, for instance, where, in the confidently sketched outline (in his paintings up till around 1910 or 1912, coloured, often red; after that time, usually dull black) showing only what is essential, he succeeds in indicating the underlying natural form. Particularly important, however, was the primary application of mutually intensifying colours, particularly cobalt blue, cadmium red, sulphur yellow, and various greens. The ignoring of the individual characteristics of visible objects means that no precise distinctions can be made. Thus, the green in the white vase of the *Still-life* can only be described as 'something green', and it would be impossible to state more precisely what it consists of. This approach made it possible for the painter to explore pictorial organization and the definition of objects on the basis of bright colours, which led to the second phase, where an answer is sought to the question of how the painter's essential resources—colour, surface, brushstroke—can be combined to make pictures primarily created as a medium of expression for colours and the activity of painting, through the suppression of objective distinctions.

The results of this second phase show that the answer to this question leads to a new distinction concerning the nature of the objective reality, where optically striking object types, like a pine tree, a rock, or cloud formation, are emphasized, as in Beckmann's late work. But problems of colour still remain the artist's primary concern.

37 Karl Schmidt-Rottluff
Still-life with White Vase, **1921**
Oil on canvas, 95 × 85 cm
Bonn, Städtische Kunstsammlungen

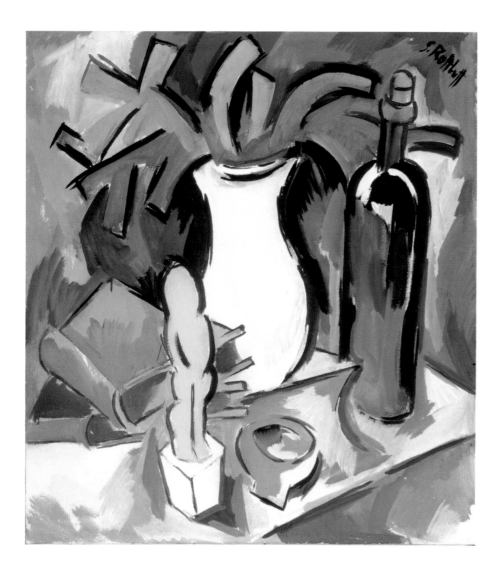

The Blaue Reiter

Campendonk Macke
Jawlensky Marc
Kandinsky Münter
Klee Feininger

Heinrich Campendonk
The Fisherman
Woodcut, 28 × 19 cm

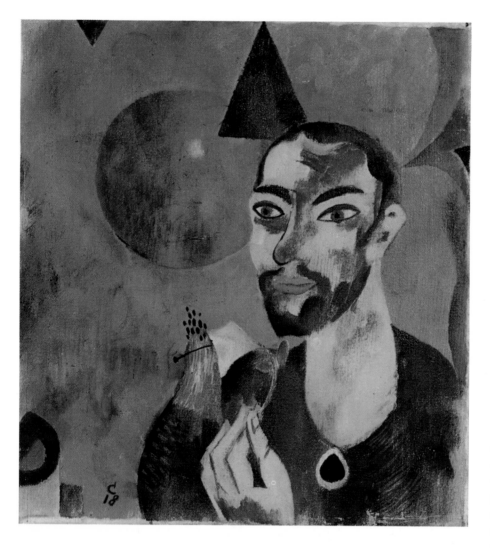

38 Heinrich Campendonk
Man with Flower, 1918
Oil on canvas, 60 × 56 cm
Amsterdam, Stedelijk Museum

The development of painting by the Brücke artists emphasized that the connection between tangible objects and the creative activity connected with their depiction does not exist *per se*, but is a historically created and developed phenomenon, which can be—and indeed has been—changed, interpreted differently, or completely ignored at any given time. This had long been familiar in art history, but at the beginning of this century it became the theme of artistic practice. This meant that the techniques and forms of pictorial composition created and used by the artist became historical and thus simply parts of developments and changes. At the same time, the artist was in the position of being able to concentrate exclusively on these changes. It was possible to use the materials of painting in order for instance to attack the problem of balance or colour innovation. In addition to the traditionally accepted endeavour of exploring how the portrayal of tangible objects, dependent respectively on the social or private situation, could be advanced and accomplished, the artists of this period also began to be interested in what could be done with artistic means as visual signs. But this distinction can only be put into practice if it is understood that colours, dabs or paint, colour forms, lines, and clusters of lines do not by definition always have to have anything to do with objects of the visible world, just because these can with their help be visually realized, any more than words must be used to give information about such objects.

This concept was particularly developed by the painters of the Blaue Reiter, and meant that the artistic approach gained its own emphasis. The exploration of the relations between colour, plane, and line led to the necessity—after beginning by explicitly abandoning objective representation—of offering a new key towards the comprehension of such pictures. This problem became particularly urgent when artists like Kandinsky and Klee began to create their own repertory of forms.

The Krefeld artist Heinrich **Campendonk** was the youngest member of the Blaue Reiter group. At the suggestion of Marc, who had seen some of his pictures, he settled in Upper Bavaria in 1911. Campendonk was a pupil of the Dutch painter Johan Thorn Prikker (1868-1932), whose work had developed out of Symbolism. His main preoccupation was with the problem created by the importance of the pictorial surface i.e. the bringing together of very different pictorial objects on the surface, without any relevance to their possible connection in the visible world. Thus, the upper head in the *Still-life* illustrated here does not belong to a body, but is related to the rest of the composition by the fact that the head of the half-figure standing underneath overlaps with it, while the lower figure is in turn connected with the rest of the objects in the composition. The outstretched hand lying in front of the breast of the half-figure, and half-covered by a tabletop whose edge points in the same direction as the hand, equally gains contact with the other objects in the picture. This kind of pictorial organization extends to the apparently random selection of objects on the table. By overlapping, they appear to be attached to one another, so that an essential decorative connection arises, emphasizing the plane, where no longer objectively identifiable objects (often geometrical forms) are used as connecting links. By means of mostly tapering extended lines which jump from one object to another, an ornamental pattern arises, underlining the overall ornamental character of the picture on this level. At the same time, the internal non-object forms thus arising serve to connect the objective and the abstract-concrete level, so that several different layers of the ornamental can now be distinguished in the composition as a whole. If the painter includes several different types of objects within the picture, and retains them within the plane, he creates at the same time the possibility of including objectively neutral material. He thus succeeds, at least potentially, in combining the abstract-concrete construction and the representational style of the picture with one another, and even in bringing them into harmony. As Paul Wember wrote: 'His works always remain a magical combination of abstraction and objectivity' (Wember, p.23).

39 Heinrich Campendonk
Still-life with Two Heads
Oil on canvas, 82 × 71.5 cm
Bonn, Städtische Kunstsammlungen

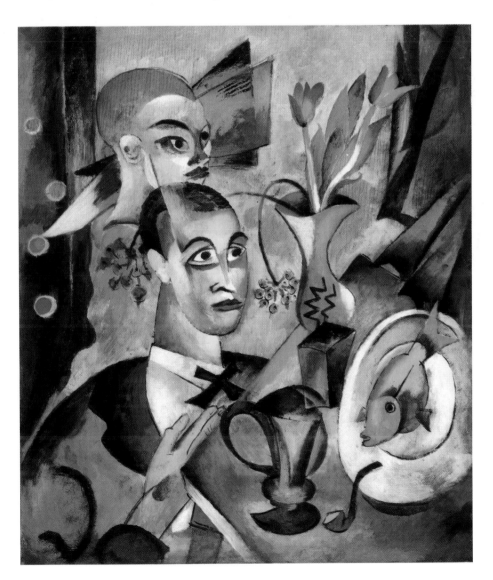

40 Alexej von Jawlensky
Girl with Peonies, **1909**
Oil on cardboard, 101 × 75 cm
Wuppertal, Von der Heydt Museum

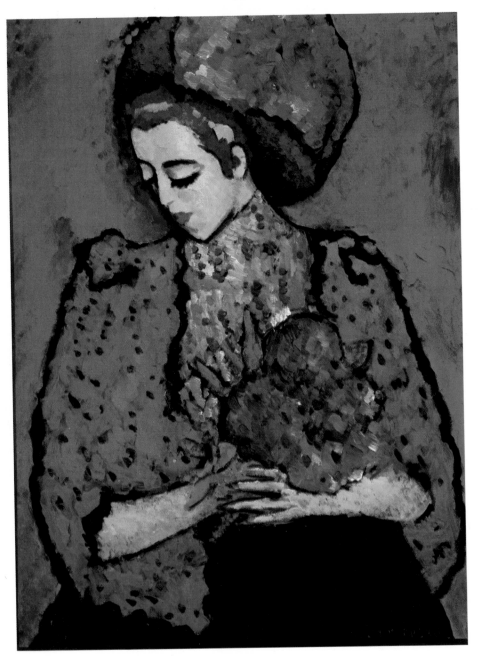

As the Expressionists sought to free pictorial means from obligatory concern with tangible objects only and with the creation of pictorial means to this end, they began to concern themselves with the different possibilities of the application of these means within the picture. This occurs through the concentration on the individual signs and their function in the picture—just as, for instance, traffic experts might be interested in whether the indication of a driver's changing direction is more effectively conveyed by an arm or a flashing light. A visual sign should not be confused with the means used to express that sign. This distinction, now made explicit in artistic activity, made it possible for the first time to discover new applications of drawing techniques, instead of a manner of representation which had reference exclusively to objects of the visible world. The artists of the Blaue Reiter achieved much in this field.

A linguistic analogy is probably the easiest way of understanding **Jawlensky's** pictures. When using the words 'tree' or 'sea' we mean both the corresponding objects in the visible world and our relation to them. We can in appropriate situations use the words 'water' and 'sea' like 'ah!' or 'oh!', as exclamations: 'Water!' 'Sea!'. In Jawlensky's work, there is a similar variety of applications. Thus, in his *Girl with Peonies*, it is not so much a female figure in a red garment with red flowers and with blue and red headgear that we see; rather, the artistic means, in particular the colour, is applied in such a way that it draws attention to itself, as though it were itself able to cry out, to exclaim: 'Look at this red!' The picture thus gradually draws the focus away from the subject, the woman in red, towards emphasis on the colour itself. On the one hand, a coloured surround (green, blue, and yellow) is provided for the dominant red, and, on the other, this portrayal of a girl with flowers is appropriate to this use of colour, and demands it, so that the red develops sumptuously, demands space, and bursts all bounds. The expanse of red is divided in two, separated by a loose black outline, and sligh- 72

tly toned down by blue dots.

Jawlensky created some landscapes in this style, but mostly painted heads and half-length portraits, which between 1911 and 1914 he simplified further, and intensified in broad forms. After the First World War, he concentrated exclusively on the human face. He reduced it to its graphic essentials, which he emphasized by contrasting the horizontal (eyes and mouth), the vertical (nose and side of the face), and curves (chin, lower part of the mouth, hairline). These essential graphic features are then complemented by subdued, sometimes pastel colouring. Jawlensky constantly achieves new variations on this theme as a paradigm for the human face, against which the individual, actual character of any one particular face may be measured. The colouring, e.g. soft violet with light grey, is sometimes reflected in the titles, like *Stilles Leuchten* ('Still Light', 1921). The pictures often have a strongly meditative character, giving a visual idea of what a face can be quintessentially reduced to, so that we learn not only to look more carefully at the faces that we see in our daily lives, but also to establish distinctions between them.

41 Alexej von Jawlensky
Variations on a Human Face, c. 1920
73 **Private Collection**

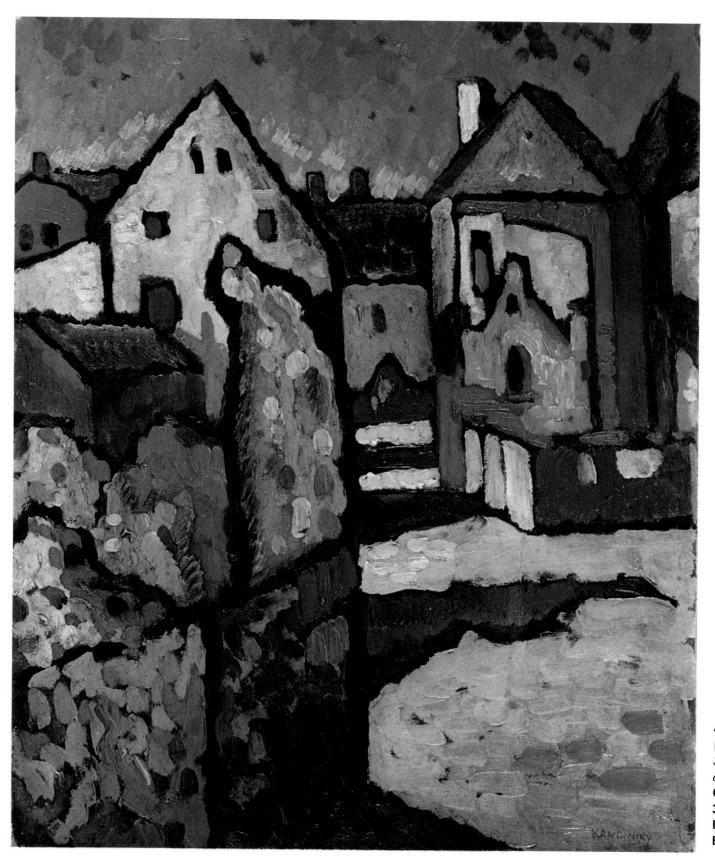

42 Wassily Kandinsky
Street Scene,
*c.*1908/10
Oil on canvas,
33 × 44.5 cm
Basle, Galerie
Beyeler 74

The use of colour without reference to objects, in which the concept of the portrayal of objects of the visible world is nevertheless preserved, was already to be found in the Fauves' work, and was considerably developed by the Brücke artists. But in artistic practice, it still lacked one step, in order to free the whole composition, (colour as well as graphic construction) from objective terms of reference. It was **Kandinsky** who took this step in 1910, with his painting of the first abstract-concrete watercolour. The step was accompanied by a theoretical comment, very clearly semiotic in its tendencies: 'Thus, if a line in a picture is freed from the aim of denoting an object, and itself functions as an object, then its inner sound is not weakened by any subsidiary role, and it gains its full inner force' (Kandinsky, *Formfrage*, p.34).

Previously, colour forms had, even when overlapping object forms, retained an implicit relation to objects. Now, however, Kandinsky went one step further in his use of colour and form, by treating them as objects, like a chair, a tree, or a house. The picture, in whose evolution the hints of objects of the visible world were no longer to be of any significance, thus became the unshackled creation of the artist. The separation of art and the visible world is complete, in that every artistic reference to it is abandoned, and the picture itself comes to represent its own visible world.

43 Wassily Kandinsky
Landscape with Houses, **1909**
Oil on canvas, 98 × 133 cm
Amsterdam, Stedelijk Museum

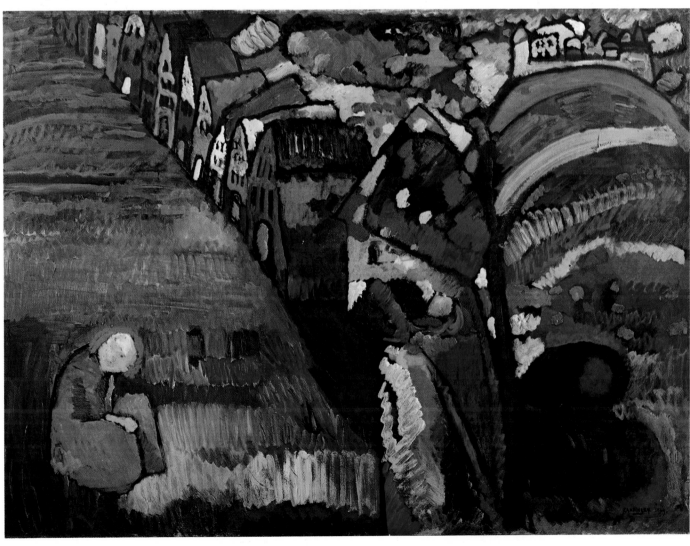

Kandinsky indicated what for him constituted the difference between 'great abstraction' and 'great realism', a distinction which continues to the present day to determine the two main directions of twentieth-century art. Whereas in 'great abstraction' the relation to and the representation of the objects of the visible world is excised, thus removing the 'objective element', in 'great realism' the artist is concerned with the 'reproduction of simple hard objects' and, when taken to its extreme, with the object itself—like the bottle drier of Marcel Duchamp (1887–1968)—restricted to the presentation of the object in a given environment.

Kandinsky's declaration that 'the "objective" reduced to its minimum must in abstraction be recognized as the most powerfully effective reality' (Kandinsky, *Formfrage*, p.30) is nothing more than the demand to see things in a completely different way, in terms of visual signs and significators, and to explore their different manners of application and their suitability for the development of a repertory of forms.

Before Kandinsky took this decisive step, he painted—in, for instance, *Street Scene*, or *Landscape with Houses*—in a Post-Impressionist or Neo-Impressionist style, with large dabs of colour, often applied with the palette knife, without completely ignoring perspective, like Derain or Schmidt-Rottluff. *Composition IV* (1911) dates from what is sometimes described as the dramatic period between 1910 and 1920, in which the developed 'individual figures' are not related to objects in the visible world, but are closely tied to the painting manner and creative act. Harmoniously combined vivid shreds and dashes of colour, violently criss-crossing and adjacent brightly coloured and dull black strokes and lines form the composition of the whole picture, which is balanced according to the interplay of

44 Wassily Kandinsky
Composition IV, **1911**
Oil on canvas, 159.5 × 250.5 cm
Düsseldorf, Kunstsammlungen
Nordrhein-Westfalen

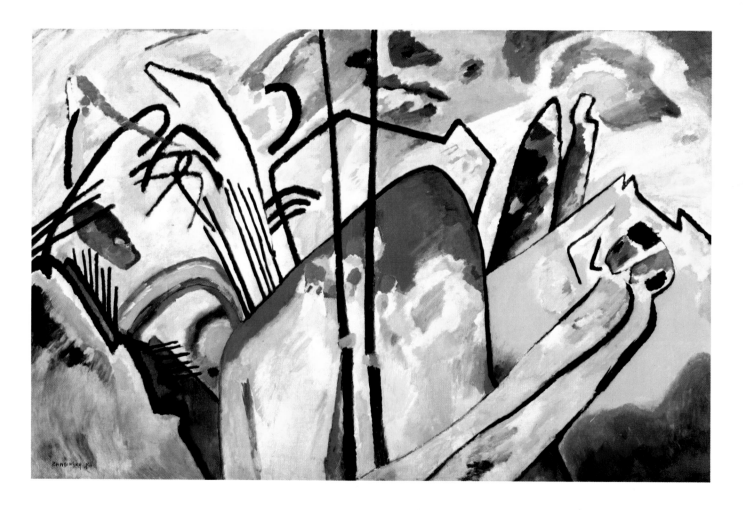

painterly and graphic elements.

His architectural period followed, between 1921 and 1924, when he used dots, clusters of lines, and sections of geometrical forms. From about 1925 on, his work consisted primarily of round, overlapping, or concentrically ordered forms, of which a description, without seeing the appropriate example, would only give the vaguest idea. Painting conceived in this way becomes a medium, whose aim is to disconcert, to question, or even to contradict a view that the observer had held to be self-evident. Here the intention is to activate and broaden the observer's patterns of experience, without needing to draw on language, just as a child playing with building blocks gradually discovers for itself what it can do with them and the different ways in which they can be used.

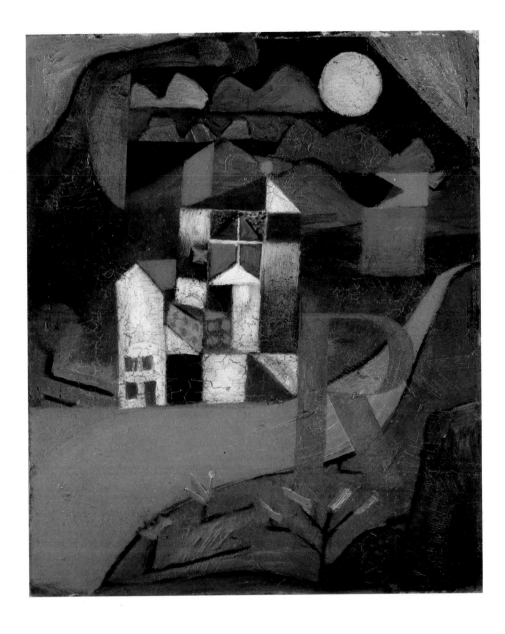

Klee, together with Picasso and Kandinsky, was one of the most versatile artists of this century. He explored many different aspects of artistic practice, and sought to build up 'artistic thought' from its first beginnings. One of his most important statements was that 'if my works sometimes create a primitive impression, then that primitiveness is based on my discipline: constant reduction. It is simply economy, i.e. the last professional perception—in other words, it is the exact

opposite of true primitiveness' (Hess, p.81). Only an observer prepared to accept this economy on the artist's part can also understand his much-quoted dictum: 'Art does not reproduce the visible, it makes visible' (Hess, p.82). At the same time, what we usually see and are able to put into words, is the visible; what we *could* see, but because of our traditional perceptions ignore for various reasons, is just what is worth making visible, if one accepts his words. The invisible

45 Paul Klee
Villa R, **1919**
Oil on cardboard, 26.5 × 22 cm
Basle, Kunstmuseum

in this very specific sense is the theme of Klee's very versatile art. He starts, as in *Villa R*, from simple forms which have no relation

46 Paul Klee
Seneccio, **1922**
Oil on canvas, 40.5 × 38 cm
Basle, Kunstmuseum

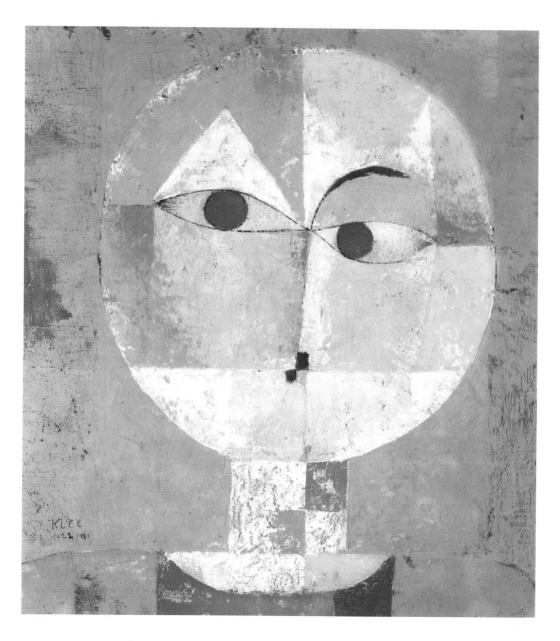

to objects of the visible world: rhombus, rectangle, semicircle, triangle, circle (disc), and letter. The picture is composed of these forms in unity with their subdued colouring, as warm and cold tones stand adjacent to each other with equivalent values. These frequently very small coloured geometrical forms are combined in such a way that the observer is in turn able to create a relation to the visible world, without at the same time being able to define the individual features which enable him to do so. As he begins to make sense of the apparently random ordering of the clearly structured forms, relations become clear, as Klee himself suggested, which the observer is suddenly able to understand as the suggestion or representation of definite objects.

Klee particularly draws attention to such relations as are not critical in our ordinary daily perceptions. For example: on seeing a mountain farm, it would be sufficient to know that it is a farm, and the individual categorization of the different buildings would be of no special importance. In his *Mountain Farm* (1934), however, Klee goes further, and visually organizes this division. Indeed, he makes it the main subject of the picture. On the basis of this approach, one could call him the painter of ignored distinctions, of those distinctions which, because of our social situation, we have not learnt to see, or which because of private interests and conflicts do not interest us.

Klee broadens our perceptions and questions or gently mocks our ingrained way of looking at things. The poetically humorous titles of his pictures, like *Struck off the List* (1933), *Look of Red* (1937), *Parting at Evening* (1922), *Clock Plant* (1924), or *This Star Teaches Bowing* (1940), do not state categorically that this or that can be found in the picture, but encourage the observer to see the picture from as many sides as possible. Klee once said: 'The titles . . . only indicate a direction felt by me. It then remains for you to accept them, and go in my direction, or to reject them and to try and find your own way—or simply be equated with an intention' (Klee, catalogue, p.7).

47 Paul Klee
Promenade, **1923**
Oil sketch/-watercolour on paper 41 × 31.5 cm, Private Collection

48 August Macke
Marienkirche with Houses and Chimney,
1911
Oil on canvas, 66 × 57.5 cm
Bonn, Städtische Kunstsammlungen

Emphasis on colour was crucial to the painting of the new era, and the natural luminosity of colours became much more important than outside illumination, so that, as in many of **Macke's** paintings, light itself becomes the theme, though this light should not be directly equated with the colours' natural luminosity, nor with the light of the Impressionists. Macke's pictures, inasmuch as they aim at rendering light, are not concerned with the liberation of colour from its task of emphasizing the appearance of objects in order to evaluate a colour according to its expression. Rather, they are interested in the actual brightness of the picture, created by

and in colour. The colours are so ordered and juxtaposed that they create one another, as complementary contrasts of red and green, blue and orange, yellow and violet. The optical activity of the observer is thus constantly being brought into play.

The Orphic painting of Robert Delaunay (1885–1951), who was represented by a few paintings at the first exhibition of the Blaue Reiter in Munich at the end of 1911, combined Cubist analysis of form and light. The different-coloured fragments, through the activity of the perceiving eye, fuse into light, so that the observer, as Goethe expressed it in the *Farbenlehre*, his treatise on colour, 'is

confronted with some of his own activity as reality'.

Macke's work was considerably influenced by Delaunay, and by his use of pure colours devloped to their full effect in Cubist forms. His *Garden on Lake Thun* is constructed in such a way that the colour pairs of the three complementary contrasts mentioned above meet in the picture. In order to achieve this, he uses the conventional thematic idea of a view from a window into a garden, thus making the colour composition immediately acceptable.

If the observer sees the colours of the complementary contrasts simultaneously, as in Macke's picture, then he experiences the heightening of their intensity, and sees how they give mutual force to one another. This is still emphasized; for red and yellow, violet and green, and so on, also clearly combine in the picture, and at the same time become simultaneously lost in the eye as perceived colours; thus, for example, the red merges with violet, the complementary of yellow, and yellow with green, the complementary of red. These contrasts both provoke and demand blue for their resolution, which is thus spread over the whole picture area. The colours become the reality of the picture, while the eye experiences more constant or more

49 August Macke
Garden on Lake Thun, **1913**
Oil on canvas, 49 × 65 cm
Bonn, Städtische Kunstsammlungen

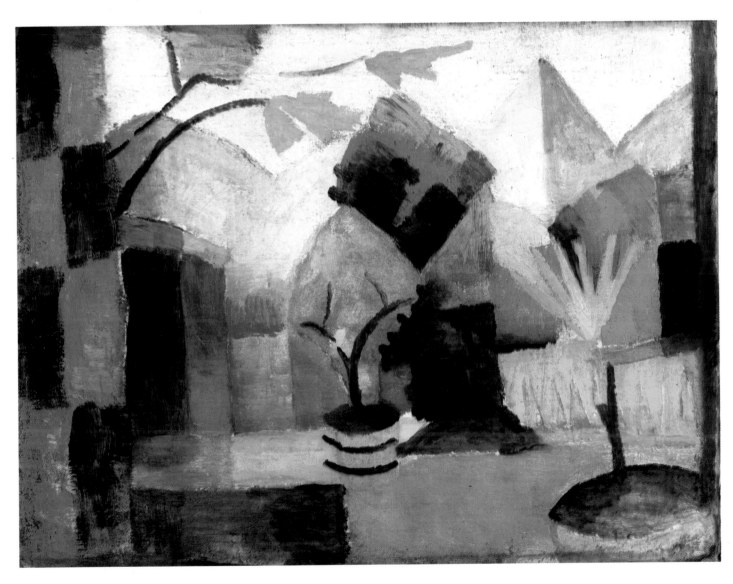

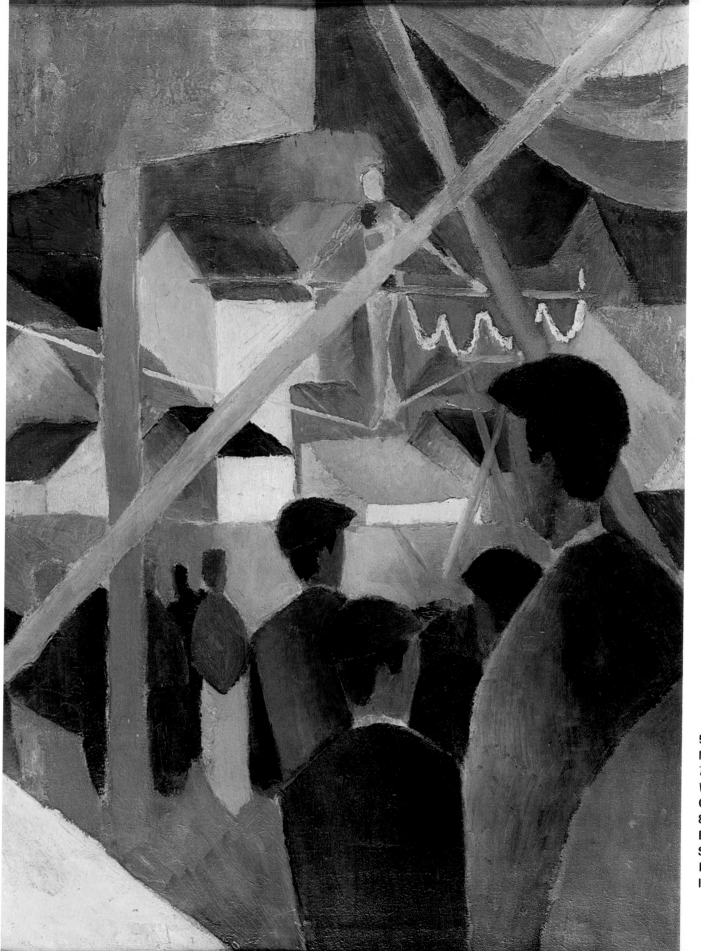

50 August
Macke
*Tightrope
Walker*, **1914**
**Oil on canvas,
82 × 60 cm
Bonn,
Städtische
Kunstsamm-
lungen** 82

dissonant colour events. This optical activity on the part of the observer, prompted by the pictorial composition, creates equivalents of light in the eye.

The laws of these various colour contrasts and optical effects had been calculated by the French chemist Chevreul in the first half of the nineteenth century (the colour practice of the Impressionists was also, incidentally, based on these considerations).

Macke's use of light only moves away from an objective relation to the visible world inasmuch as this is necessary for the rendering of the light. He painted happy, optimistic pictures: walks along the shore of a lake, children, young girls under trees, women in front of shop windows, elegantly dressed people in a sunny landscape or in zoological gardens.

In 1914, Macke visited Tunis together with Klee and discovered how the coloured cubes of the Moorish towns were particularly suited to his light painting, and close to it in spirit. In an undated note, Macke summarized his artistic aims: 'The lifelike quality of a painted surface is created through movement, which arises in the observer through the simultaneous resonance of red and blue, lines and curves, and so on. The way in which an artist makes the reds in a picture dominate or intensifies the blues, the way in which he organizes this whole tension, is the highest form of mathematics, impossible to express in words' (quoted in the *Der Blaue Reiter* catalogue).

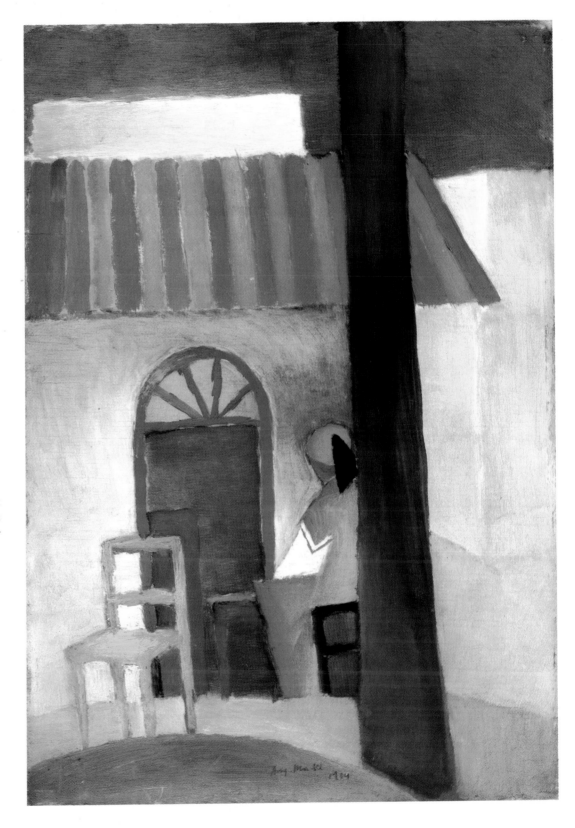

51 August Macke
Turkish Café, **1914**
Oil on canvas, 35.5 × 25 cm
83 **Bonn, Städtische Kunstsammlungen**

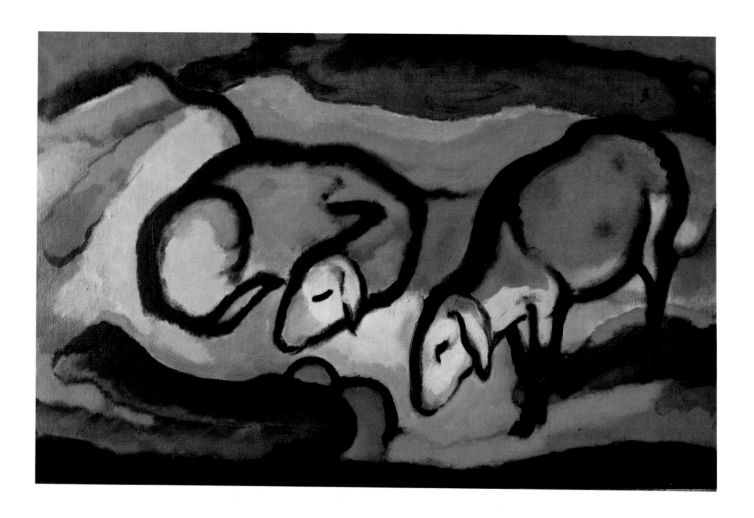

52 Franz Marc
Sheep, **1912**
Oil on canvas, 49.5 × 77 cm
**Saarbrücken, Saarland Museum, Neue
Galerie**

In a letter dated 12 June 1914, **Marc** wrote
to his friend August Macke: 'What does the
"peinture" of the Orphists matter to me? We
Germans are and will be born draughtsmen
and illustrators, even when we are painters'
(Haftmann, p.62).

In these two sentence, the artist succinct-
ly sums up the underlying approach to the
colour composition of all his work. On his
subject matter (his animal paintings made
him very popular), he commented in a letter to
Reinhard Piper, the publisher of *Der Blaue
Reiter*: 'I seek to intensify my feeling for the
organic rhythm of all things, and seek to feel
pantheistic empathy for the trembling and
flowing of blood in nature, in the trees, in
animals, in the air . . . I see no more suitable
way of "animalizing" art, as I like to call it,
than the animal picture, and that is why I have

been attracted by this' (Marc catalogue).

In *Sheep* (1912), the figural composition
is determined by a broad black outline reveal-
ing a close acquaintance with Jugendstil. The
greyish-white heads are more or less
naturalistically coloured, but the bright
colours show through the silhouettes of the
sheep, thus forming an overlapping grouping
of colours and creating the overall impression
of a meadow or landscape.

Marc takes the line of Jugenstil and the
colouring of Fauvism, and adapts Delaunay's
light painting in such a way that the colours
are no longer used to portray light, but belong
to the objects represented. In order to show
the 'inner connection' between the life of the
animal and its natural environment, the
colours shine through the surface of the
painting as though through painted glass. 84

Animals, as natural objects, take on transparent colouring, and appear as object colours, as needed by the artist. For Marc, the highest duty of art is 'to create *symbols*, symbols behind which the technical heritage cannot be seen' (*The* Blaue Reiter *Almanac*, p.64). Marc is concerned not simply to paint the coloured appearance of objects, nor to free colour in the picture from objects entirely. In order to heighten the symbolic force, he attaches colour to pictorial objects and establishes a familiar colour symbolism in his pictures, where he makes the colours move as though caught in the light and left in the shade. He wrote to Macke in 1910: 'You know my tendency is always to imagine things in my head and to work from this idea. I am going to explain my theory of blue, yellow, and red, which will probably seem as "Spanish" to you as my face.

'Blue is the male principle, astringent and spiritual. Yellow the female principle, gentle, gay, and sensual. Red is matter, brutal and heavy and always the colour to be opposed and overcome by the other two!

'For example, if you mix serious, spiritual blue with red, you intensify the blue to unbearable sorrow, and yellow the con-

53 Franz Marc
The Two Cats, 1912
Oil on canvas, 74 × 98 cm
Basle, Kunstmuseum

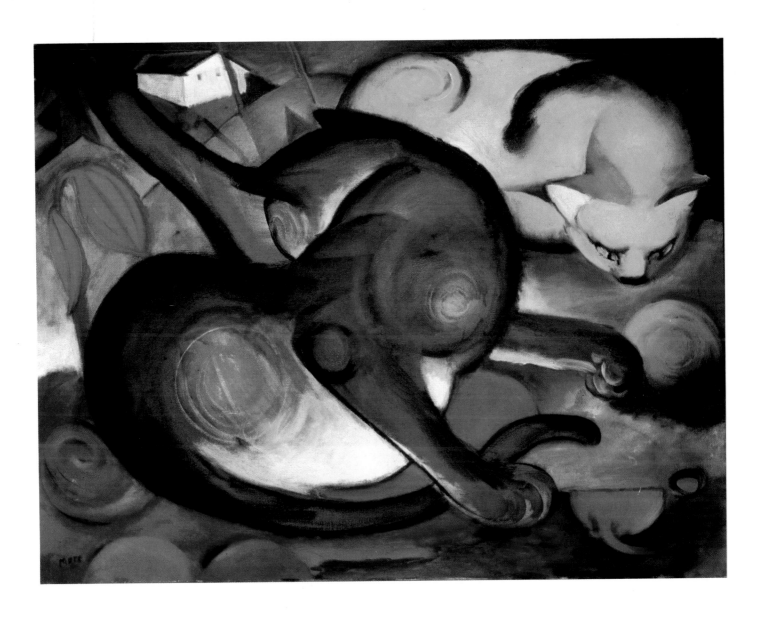

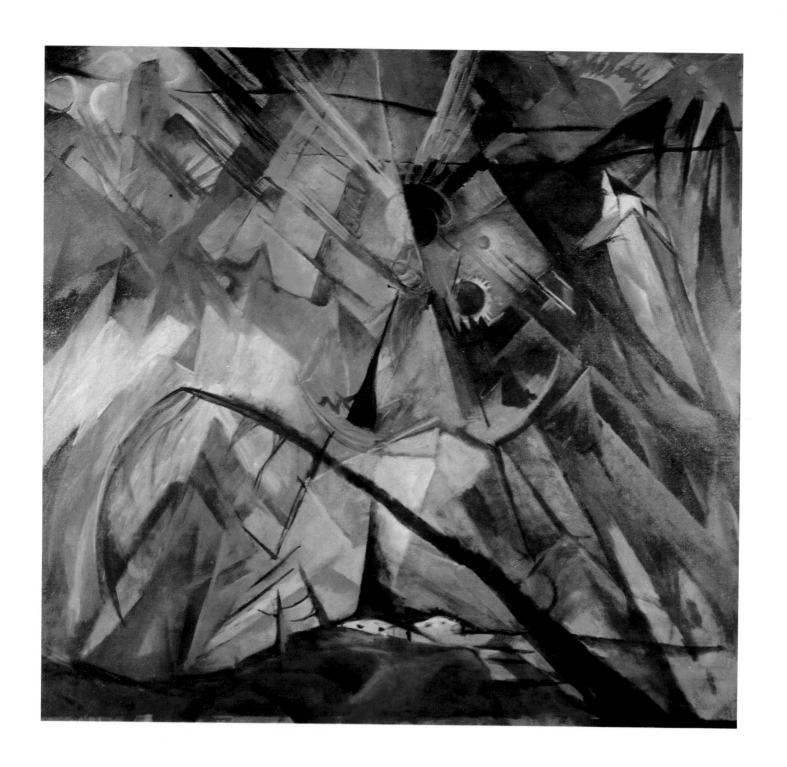

54 Franz Marc
Tyrol, **1913/14**
Oil on canvas, **136 × 144 cm**
Munich, Bayerische
Staatsgemäldesammlungen

ciliatory, the complementary to purple, becomes indispensable. (Woman as consoler, not as lover!)

'If you mix red and yellow to make orange, you turn passive, feminine yellow into a Fury, with a sensual force that again makes cool, spiritual blue indispensable, the man; and in fact blue always places itself at once and automatically at the side of orange: the colours love each other. Blue and orange, a thoroughly festive sound.

'But then if you mix blue and yellow to make green, you arouse red, matter, the "earth", but here, as a painter, I always sense a difference: it is never possible altogether to subdue matter, brutal red with green alone, as with the other colour chords. (Just think of some handicraft objects in red and green!) Green always needs the help of some more blue (sky) and yellow (sun) in order to silence matter' (Dube, pp.128f.).

55 Franz Marc
Landscape with House and Two Cattle
Oil on canvas, 67 × 71.5 cm
Munich, Galerie O. Stangl

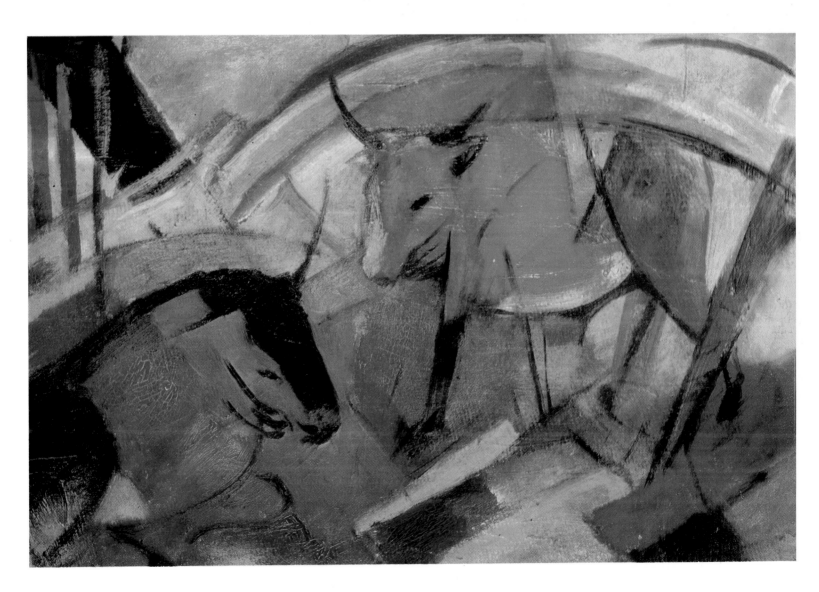

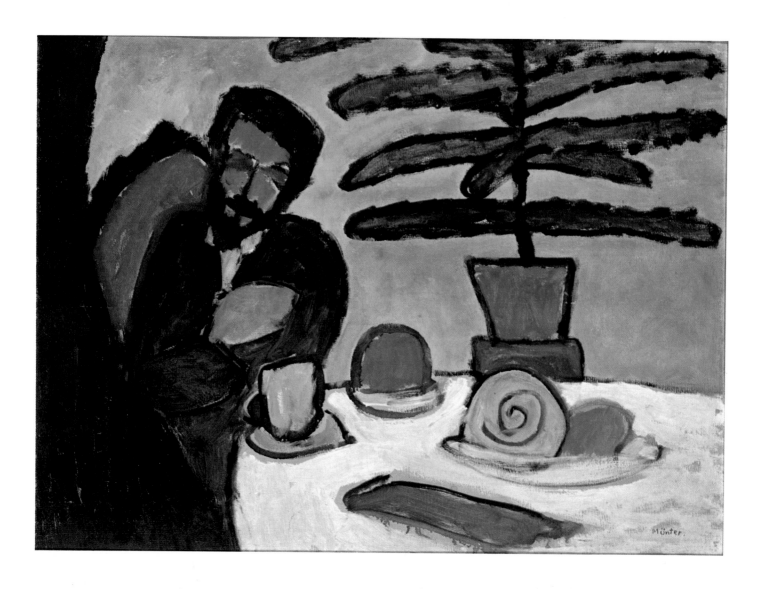

56 Gabriele Münter
Kandinsky at Table, **1911**
Oil on cardboard, 52 × 72 cm
**Munich, Städtische Galerie im
Lenbachhaus**

Together with Paula Modersohn-Becker and Marianne von Werefkin, Gabriele **Münter** is the third woman artist of note on the Expressionist scene. As Kandinsky's companion, she was until 1915 artistically in the shadow of his art.

Münter had at an early stage got away from heavy *atelier* art, and her paintings, like *Tree Blossom in Lana* (1908), began to shine. Here there is already a suggestion of the originality which she retained right up to her late flower pictures: the endeavour to represent the objective coloured essence of a motif, so that a barely closed circle with a dot could clearly be seen to be a flower, or a green colour form could be discerned as a mass of leaves, without needing any details.

She seems to seize on a subject—a landscape, or a flower—and then, within this thematic framework, uses colour and draughtsmanship in such a way that the observer, if he accepts the framework, has his eyes opened by the picture, and misses nothing, even though everything is greatly simplified and 'blown up', both in terms of colour and and draughtsmanship. This results in a harmony between the picture and the observer's visual patterns of experience, which the whole composition of the picture draws on in order to create its effect.

Feininger had begun his career as a caricaturist in Berlin, after leaving the Academy in 1884. In 1905 he began to move towards painting. In a letter to his wife written in the same year, he told her that the starting point for his artistic aspirations was to depict the reflection of glass, its silvery iridiscent quality and the light reflected on polished objects. After meeting Delaunay and the Cubists in 1908, Feininger devoted himself entirely to painting. His pictures are composed of delicately coloured cubes, and do not attempt to combine plane and perspective. Unlike the Cubists, he did not aim for multiple views of objects, but used the cubic structure of the pictorial composition to juxtapose and superimpose the transparent colours, so that they always remain related to the object. We know that he prepared completely conventional sketches of his subjects, and would then translate them into cubic-prismatic structures, which, in a picture like *Bridge III*, would present no problems. He preferred objects which were intrinsically suitable for his intention—churches, bridges, boats, and so on. He became more and more interested in architectural forms throughout his work.

57 Lyonel Feininger
Bridge III, **1917**
Oil on canvas, 80 × 100 cm
Cologne, Wallraf-Richartz Museum

Watercolour, particularly suited to transparency of colour and form, also played an important part in his work.

Feininger's pictures, like Marc's, were among the most genuinely popular works of this period, no doubt not least because of their objective conception and the accuracy of the artistic representation which satisfied the observer's expectations. The works are 'cleanly' and 'decently' painted, and contain highly aesthetic moments. They lack the artistic aggression of, say, some of the Brücke painters' work. As regards historical

58 Lyonel Feininger
Paddle Steamer, **1913**
Oil on canvas, 81 × 100.5 cm
Detroit, The Detroit Institute of Arts

influence, it can fairly be said that the development of individual Expressionist artists, inasmuch as they placed the main emphasis on artistic visual problems, was of considerable significance for subsequent artistic developments.

Independent Expressionists

Hofer	Meidner
Kokoschka	Modersohn-Becker
Kubin	Rohlfs

Christian Rohlfs
The Prisoner
Woodcut

59 Karl Hofer
Tessin Landscape, 1930
Oil on canvas, 70.5 × 100 cm
Cologne, Wallraf-Richartz Museum

After modest and rather academic beginnings, **Hofer** turned to Expressionism relatively late, in 1919. His earliest paintings of this period—*The Drummer* (1919) or *Portrait of Alfred Flechtheim* (1922)—show the influence of the Brücke group, but the link with Expressionist art is clearest in his interest in African art. Hofer always avoided the powerful, shrill, or abrupt in his art, which has a bleak, unimpassioned quality, typical of what became known, in contrast to Expressionism, as Neue Sachlichkeit ('New Objectivity'), and elsewhere is described as Neo-Realism.

Hofer's painting—as *Tessin Landscape*, for instance, indicates—was balanced and matter-of-fact, occasionally rather dry and sober. In addition to landscapes, he often painted couples, masked figures, and girls.

The construction of his works is clearcut, often based on cubic forms, and he sought the severe, clearly defined quality that he found in Cézanne's painting. He himself commented: 'I possessed the Romantic; I have sought the Classical' (Myers, p.79), and, elsewhere: 'My work was in opposition to the fashion of the day, as it has remained to the present time. But the portrayal of natural beauty is of primary importance ... The depiction of ugliness, sought out because of world-weariness or rebellion, has the advantage, however, of not attempting to simulate any artistic quality through the beauty of an object' (Hofer, pp.14ff.).

Kokoschka's painting, inasmuch as it can be described as Expressionist, is closest to that of Emil Nolde, apart from a series of psychologically expressive portraits like those of the scientist Forel (1910), or of the *Sturm* publisher Walden (1910). Kokoschka is an artistic double talent, whose achievements and aims as a writer and as a painter have influenced and complemented one another. Thus, in his plays *Mörder, Hoffnung der Frauen* ('Murderer, Women's Hope', 1907, set to music by Hindemith in 1920) and *Sphinx und Strohman* ('Sphinx and Man of Straw', 1907), he deals with the confrontation and battle of the sexes, already a central theme in Strindberg's work, which the painter-writer sets in a mythological context. The psychological insight and directness of his pictures was, in spite of their traditional construction, what Vienna found especially shockingly unrespectable and insulting. In 1908, Kokoschka held his first exhibition in Vienna, at the same time as the première of *Mörder, Hoffnung der Frauen*, the first Expressionist work to be performed on stage. He had started his career as a graphic artist

60 Oskar Kokoschka
Portrait of Nell Walden, **1916**
Oil on canvas, 97 × 78 cm
Krefeld, Private Collection

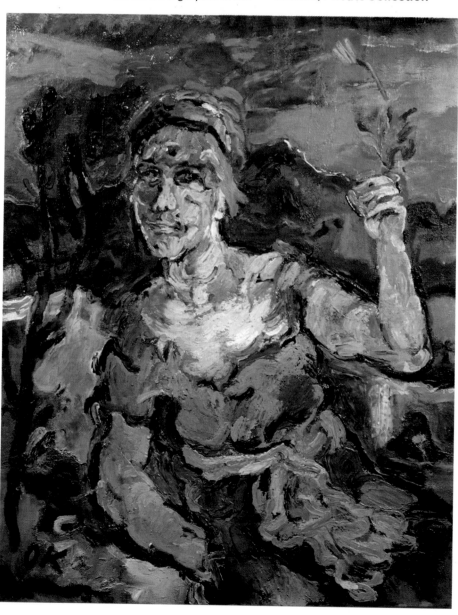

and illustrator, and taught himself painting.

The subject and construction of *The Power of Music* were typical of his painting of between 1915 and 1924, described by Werner Haftmann as 'dramatic Impressionism'. The painting gives a visual depiction of music, such as had been a traditional subject in painting since the Renaissance. In Giorgione/Titian's *Open-air Concert* (1508/10), Gerard Terborch's *Music Lesson* (1675), or Adolf von Menzel's *Friedrich II's Flute Concerto in Sanssouci* (1850/52), music is portrayed as a social event, a scene of communal activity with performers and audience. Kokoschka, on the other hand, depicts the *effect* of music—the way that it is able to frighten, to seduce, and to repel. We see a figure facing towards us, cut off by the bottom left-hand edge, with some kind of wind instrument at his lips, and a flower in his left hand, approximately marking the centre of the picture; on the right is a huddled figure, turning away from the phenomenon of music, and raising his hands in a defensive position. This same idea of turning away recurs in the inconspicuous dog running off into the background at the top of the picture. The dramatic movement is from left to right across the painting, following the diagonal direction indicated by the performer's instrument. In the picture we are presented with a colour phenomenon, where both figures are clearly related, since the musician is in green, while the figure surprised by the power of music is essentially in red. These two colours, relating and contrasting the two figures, are combined with two further colours: the yellow of trousers, face, and arm, and the violet, particularly of the flower. The orange of the right-hand figure

61 Oskar Kokoschka
The Power of Music, **1918**
Oil on canvas, 102 × 150 cm
Eindhoven, Stedelijk van Abbemuseum

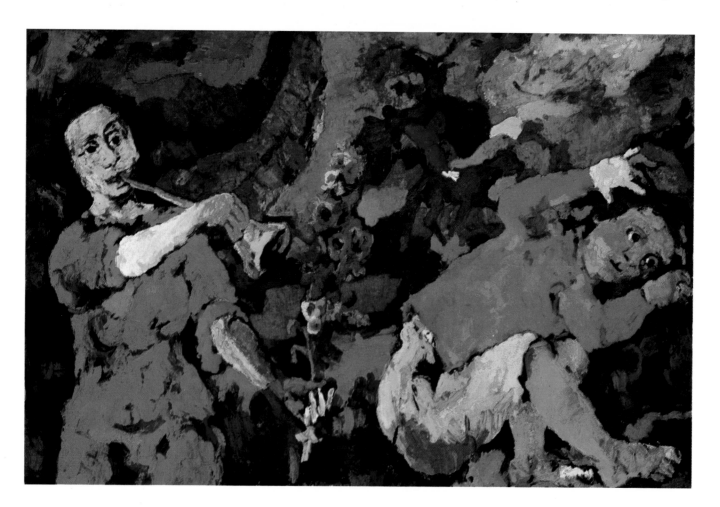

balances the blue in the upper half of the picture. At the same time, the colours never go beyond the objective form and exist in the picture as pure colour phenomena. Kokoschka's pictures from this period reveal a combination and opposition of colours which not only support the thematic intention, but actually make it possible in the first place. The paint is applied *impasto* to the canvas, as in the *Portait of Nell Walden*, giving it a directly material and decorative charm, manifested in each picture in a different way. The canvas, daubed with paint, apostrophizes the object, as it were. Kokoschka's favourite themes include landscapes and urban views as well as portraits and figure compositions. Whereas in the portraits he seeks to convey the psychological state of a person at any particular time, in his landscapes and urban views he effectively attempts to represent their geographical, climatic, and historically conditioned individual character.

Very much in accordance with Western tradition, Kokoschka sees visual art essentially as a medium of communication. 'Visual art', he wrote, 'is a language of images, visible or tangible signs, a knowledge of images based on experience, comprehensible, by means of which the artist's vision becomes for the next person, the person of the future, an experience shared by all humanity and existence. Visual art has in common with language the fact that the content of the statement must be expressed in evident symbols, in order to make it comprehensible' (Kokoschka, p.407).

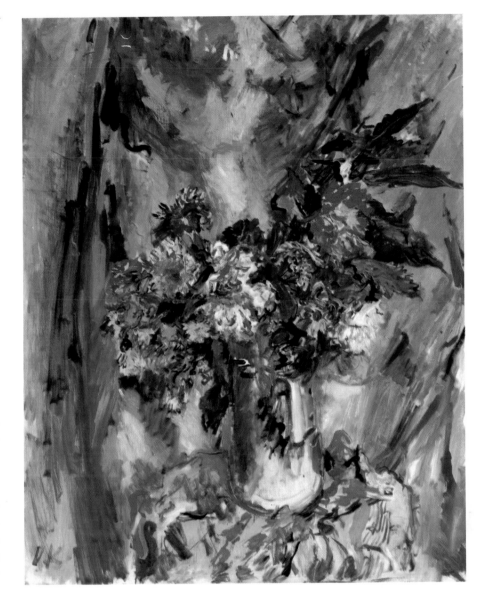

62 Oskar Kokoschka
Bunch of Autumn Flowers, *c.***1928**
Oil on canvas, 100 × 80 cm
95 Lugano, Private Collection

Kubin was almost exclusively a graphic artist and illustrator. 3,500 of his sketches are preserved in the Linz archive alone, and an almost equal number is in the Albertina in Vienna. He illustrated works by, among others, E. T. A. Hoffmann and Edgar Allan Poe. His art is suspended between symbolism and mythology, and stands poised between a remote fairytale quality and gross triviality. Klee described the subject matter of Kubin's sketches as 'a morass of phenomena'. In his fantastic novel *Die andere Seite* ('The Other Side', 1909), recently filmed as *Traumstadt* ('Dream Town') dream and reality constantly merge, and the very detailed representation of the first-person narrator recurs in the sketches. Decadence and visions of destruction are central to both his novel and his graphic work. The drawings are so constructed that the observer gets the impression that the subject (which Kubin inevitably knew only from literature) somehow slipped out of the artist's grasp. W. Hofmann gave a succinct description of Kubin's artistic intentions: 'every border area has pervious areas, in which both regions gradually grow together and form strange combinations. Here, between day and night, in the twilight, the outline of things only becomes crucial when it is seen from two angles, from this side and from that. . . . That is the mysterious setting of Kubin's world: the point at which the trivial meets with the horrific, where the familiar suddenly becomes a distorted grimace' (Kubin catalogue, foreword).

63 Alfred Kubin *The Snake Charmer*, c.**1908–9 Watercolour, 23.7** x **27.3 cm Saarbrücken, Saarland Museum, Neue Galerie**

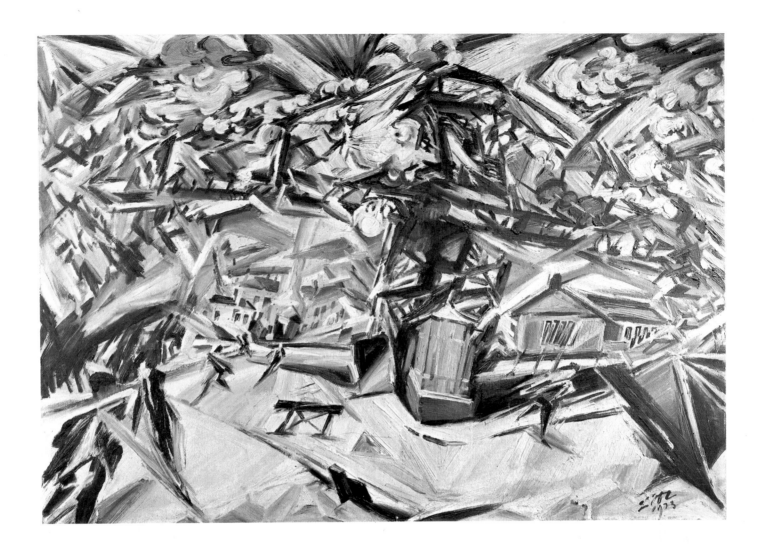

The geometrical cubic analysis of form, especially suitable for light representation, and brilliantly used by Macke, following in Delaunay's footsteps, was adopted by **Meidner** to give a dramatic meaning to the visible world. The theme of Cubist multiple perspective is reinterpreted in his work as an apocalyptic view of the urban landscape. The focus of *Apocalyptic Landscape* is concentrated in the middle distance, and the eye is drawn past the void of the foreground towards the coarse, black, broken lines which combine to form juxtaposed and colliding forms. A tower-like building is suggested, and a yellowish-green, absorbed by a little pale violet and ochre, encroaches on the dominant dirty grey-white colour. A destructive explo-

64 Ludwig Meidner
Apocalyptic Landscape, **1913**
Oil on canvas, 81 × 116 cm
Saarbrücken, Saarland Museum, Neue Galerie

sion thus becomes the theme of the picture. The composition was undoubtedly determined by the immediate pre-war situation with its uncertainties. Meidner's other pictures often reinforce such an impression, without emphasizing a visual problem. Meidner wrote of his own condition: 'How the cell-like colour of my studio scorched me. I was never stabbed by the bloody knives of the

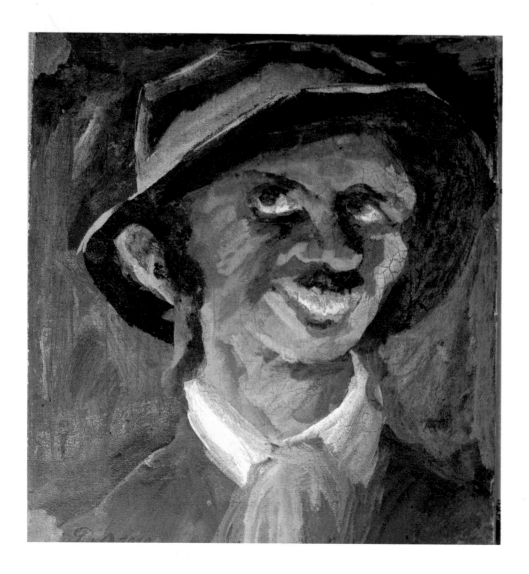

sun. But I became brown as in August. The desert summer baked in me, with vultures, skeletons, and screaming thirst. I cried out for the rattle of the distance and the trumpet calls of future catastrophes. Did I not have to paint trickles of blood and gnawed wounds in my self-portraits?! Did I not love the comet tail and blazing volcanoes! I scratched, rubbed, and sharpened my colours. But miserably I tore at the body, which, draped in an armour of colour, glowed in the cruelly screaming itch' (Meidner, pp.6f.). In 1912 Meidner founded 'Die Pathetiker' ('The Pathetic Ones'), who were concerned with pathetic emotion, empathy and sympathy, the ecstatic spiritual life which Meidner considered that the Brücke artists, for example, did not sufficiently emphasize. The group, whose works were first exhibited by Herwarth Walden in the same year, broke up shortly after this exhibition, because of the unexpected success that it brought to Meidner. Kurt Hiller wrote of the exhibition in *Aktion*: 'The best of what Meidner has to offer are not bewildering painter's tricks and gimmicks, but artistic statements, a sense of experience and of mental anguish . . . Here we have someone who is not deliberately nebulous, and not simply playing games, but a suffering creator. His work is not especially innovatory, and there is perhaps something lacking in his composition, his line and the extreme degree of simplicity; he has not yet achieved . . . sacred simplicity, but—and this is the important thing—he is human, human, human' (Hiller, cols. 1514ff.).

65 Ludwig Meidner
Self-portrait, **1923**
Oil on canvas, 29 × 27.5 cm
Saarbrücken, Saarland Museum, Neue Galerie

Paula **Modersohn-Becker** died at the age of thirty-one, after only twelve years' working life. It is only now, seventy years after her death, that her work is finally beginning to be fully appreciated.

She sought to reveal the *essence* of her subject: thus, for instance, she was not interested in committing to canvas some random expression on the face of her poet friend Rilke, nor to portray him simply as he sometimes looked—his 'formal face', or the face which shows intellectual strain or physical privation. She was concerned first and foremost to concentrate on the 'common factor'—what made him sometimes one thing, sometimes another. She managed by

66 Paula Modersohn-Becker
East Frisian Girl in the Dunes, **1903**
Oil on canvas, 50 × 54 cm
Groningen, Groningen Museum

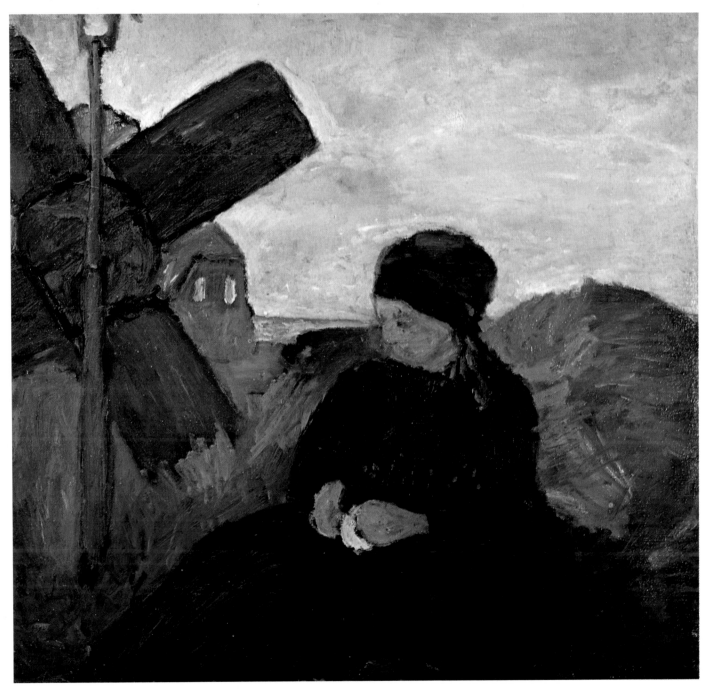

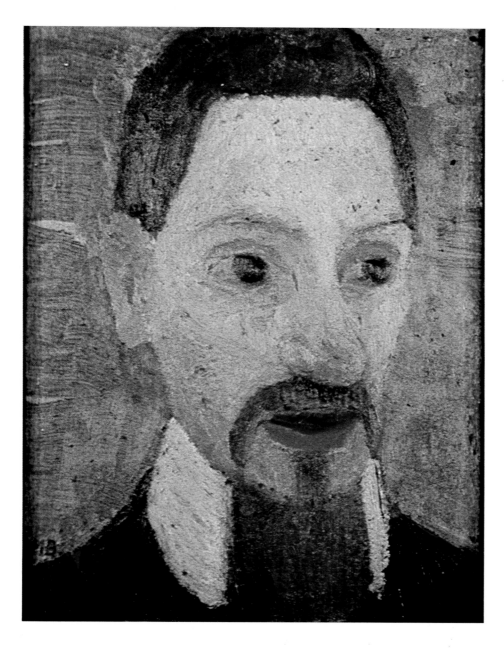

67 Paula Modersohn-Becker
Portrait of Rainer Maria Rilke, **1906**
Oil on canvas, 34 × 26 cm
Bremen, Roselius Collection

with bringing her experiences with the Parisian artistic avant-garde to Germany, she also became one of the pioneers of the new era in art, and her pictures were understood neither by the public nor by the critics. In her lifetime, she sold only two; when she painted a picture for a tombola in Worpswede on one occasion, the winner exchanged it for another prize. When she had her first exhibition at the Bremen Kunsthalle in 1899, the critics wrote without any understanding, both tactlessly and senselessly: 'If one should have the misfortune to hear a disgusting story from some coarse fellow, it is for a long time impossible to think either of food or drink; and so it is that thinking of our Kunsthalle has become repellent at the moment ...' Vinnen supported this verdict, and wrote: 'Certainly we believe the works in question to be inferior and immature, and for various reasons we should have preferred them not to have been exhibited' (Augustiny, p.3). On her death, Rilke wrote his famous *Requiem for a Friend*, where he attempts to relate his interpretation of Cézanne's works, which he had expounded in his letters, to Paula Modersohn-Becker's work:

> For that was what you understood: full
> fruits.
> You used to set them out in bowls before
> you
> and counterpoise their heaviness with
> colours.
> And women too appeared to you as fruits,
> and children too, both of them from within
> impelled into the forms of their existence.
> And finally you saw yourself as fruit,
> Lifted yourself out of your clothes and
> carried
> that self before the mirror, let it in
> up to your gaze; which remained, large, in
> front,
> and did not say, that's me; no, but: this is.
> So unenquiring was your gaze at last,
> so unpossessive and so truly poor,
> it wanted even you no longer: holy.
>
> (tr. J. B. Leishman)

the simplest means to suggest the single constant that underlay the random changes. Rilke's portrait is painted in such a way that the face is equally dominated by mouth and eyes. It is entirely mouth and eyes. Paula Modersohn/Becker can be credited not only

It was Theodor Storm who paved the way for Christian **Rohlfs,** a farmer's son, to become a painter. Rohlfs is the oldest of the painters represented here, and continued painting into old age.

He began at an early age to attempt to order the randomness of the visible world through painting. There is a contemplative realism about his landscapes and sensitive lifelike portrayals, and the apparently random quality can on closer examination be seen to be the result of careful but inconspicuous organization, as in *The Wild Moat* (1888), or *Spring Landscape* (1900). His simple landscapes have a well-ordered tranquility about them.

In 1936 an exhibition of Rohlfs' in Bremen was closed by the Nazis, and in 1937 they confiscated more than 400 of his works.

After an Impressionist phase, he turned to a manner much closer to Expressionism. Without being particularly introvert or recluse, isolated from contemporary art development, he nevertheless followed his own path to a considerable extent, and kept away from the main art centres, though he regularly sent pictures to the main exhibitions, such as those of the Berlin Secession.

68 Christian Rohlfs
The Tower of the Patroclus Cathedral in Soest, **1906**
Oil on canvas, 100 × 80 cm
101 **Essen, Folkwang Museum**

In 1904, Rohlfs visited Soest for the first time, from Hagen, where he had been a teacher at the Folkwang school since 1901. In 1905 he returned to the 'glorious nest', and spent the summer of 1906 painting there, during which time he got to know Emil Nolde. His Soest pictures have become well known, particularly those with the tower of St. Patroclus.

Rohlfs was a cultivated painter, and a master of technique. His often large-scale paintings in water tempera, for example, were highly controlled in their brushstroke. He sometimes experimented with his materials, though this never became his central preoccupation.

The contemplative tranquillity of the early landscapes was replaced by a kind of crystalline mesh in the mature works, where one gets the impression that this mesh has been cast over the whole picture so that the observer can only perceive the objects through this prism.

69 Christian Rohlfs
Church in Soest, **1918**
Tempera on canvas, 100 × 61 cm
Mannheim, Kunsthalle

From Expressionism to Neue Sachlichkeit

Beckmann
Dix
Grosz

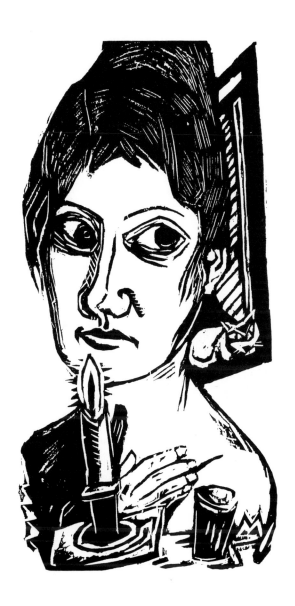

Max Beckmann
Woman with Candle, **1920**
Woodcut, 30 × 15 cm

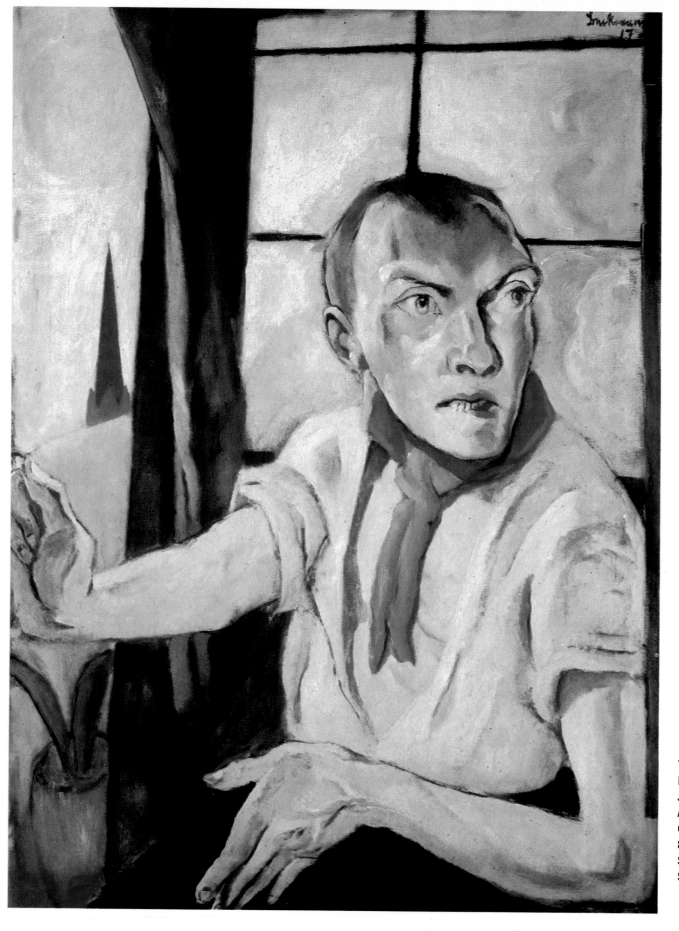

70 Max
Beckmann
*Self-portrait with
Red Scarf*, 1917
Oil on canvas,
80 × 60 cm
Stuttgart,
Staatsgalerie

104

After the First World War, the artists of the Post-Expressionist generation, especially Otto Dix and George Grosz, took up the techniques of Expressionism. The original purely artistic aims tended to be replaced by a much greater emphasis on social criticism, against the background of the relative stabilization, the 'borrowed prosperity', to use H. Böhme's phrase, of the Weimar Republic. Whereas the original Expressionism sought a new conception of artistic activity and tended towards the abstract concrete, 'Post-Expressionism', 'Magic Realism' and 'Neue Sachlichkeit' ('New Objectivity')—all different names spanning the range of a single movement—were concerned, very much in the spirit of Kandinsky's realism, to give all objects and phenomena of the visible world a simple and firm visuality, by accurately reproducing their objective reality. The 'destruction of form' (as Gottfried Benn expressed it) was to be replaced by

71 Max Beckmann
Night, **1918/19**
Oil on canvas, 133 × 154 cm
Düsseldorf, Kunstsammlung Nordrhein-Westfalen

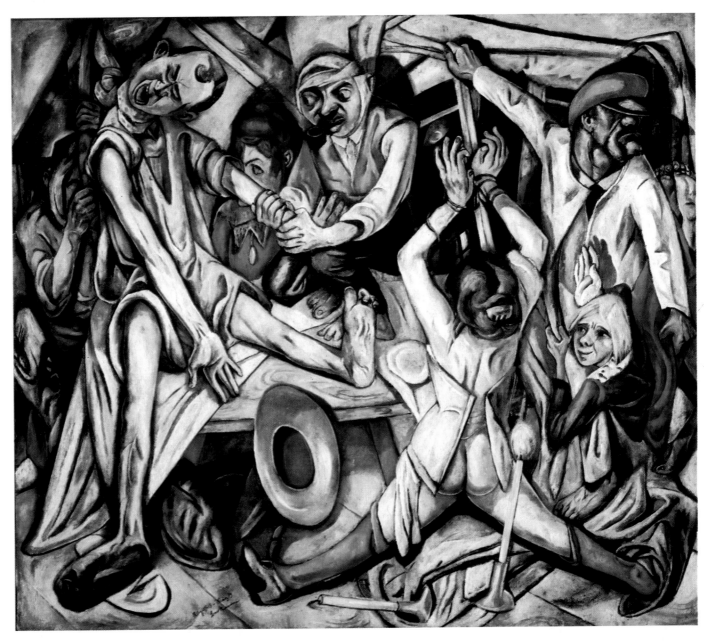

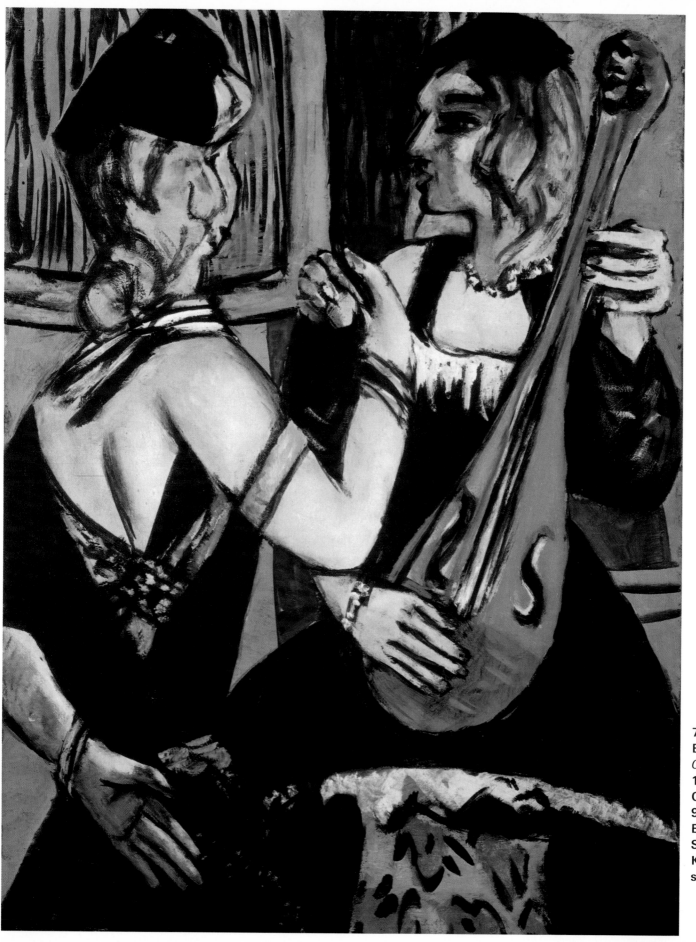

**72 Max
Beckmann**
Cabaret Artistes,
**1943
Oil on canvas,
95 × 70 cm
Bonn,
Städtische
Kunst-
sammlungen** 106

'fixing of form', a reaction to the objectivity and matter-of-fact quality of modern industrial society. This produced a tendency not only stabilizing, but also critically committed in its broadest sense.

While 'self-expressionism of the objective world' is an aspect of Neue Sachlichkeit, **Beckmann** aimed in his confrontation with the visible world to determine the pattern of experience of visual relations to it, in a set of symbols specially formulated for that purpose. He created his self-portraits essentially as a visual image of the way in which he was personally affected by the period, as recorded in countless diary entries. The portraits often express the search for the self and for its standpoint, its relation to the period.

In 1920 Beckmann wrote in his *Artist's Confession*: 'We must abandon our heart and nerves to the terrible cry of pain of the poor deceived man. It is now that we must be as close as possible to man. That is the only thing that can to some extent motivate our essentially superfluous and self-centred existence. Let us give man a picture of his fate—and one can only do that if one loves him' (Schmied, p.243). In addition to his self-portraits, which he painted throughout his career, Beckmann painted mostly narrow, upright landscapes and developed a particular type of figural composition, often with a mythological subject (e.g. the last triptych *The Argonauts*, 1950), The figures are shown huddled together in a slightly off-perpendicular perspective, as is shown by the various perspectives. These different points of perspective are often emphasized by the tying down and extending of limbs and their extreme overlapping. In this thematic context, Beckmann invents pictorial symbols, which he then himself quotes in different forms in his pictures.

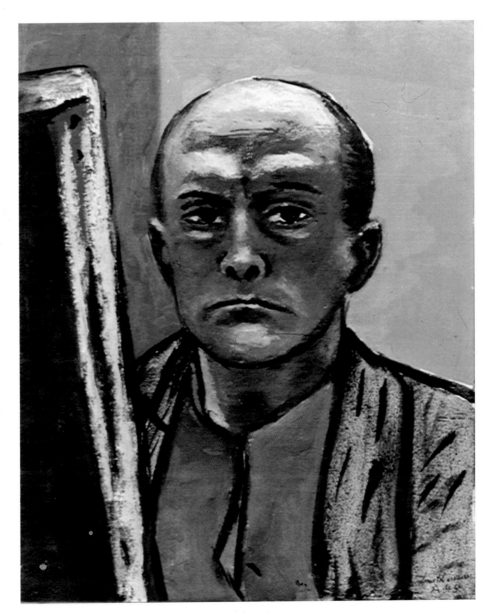

73 Max Beckmann
Self-portrait before the Easel, **1945**
Oil on canvas, 60.5 × 50 cm
107 Detroit, The Detroit Institute of Arts

74 Otto Dix
My Parents, **1924**
Oil on canvas, 118 × 130 cm
Hanover, Niedersächsische
Landesgalerie

As a soldier at the front, Otto **Dix** had experienced all the horrors of war. In order to be able to concentrate on the expression of his war experiences and what resulted from them, he did indeed start from Expressionism, and returned to it again in his old age; but in order to achieve representational clarity, he became a painter who painted absolutely realistically—in other words, with a verism which sought an almost fantastic clarity, in order to be able to depict unpleasant or repulsive situations. In

doing this, he covers the whole gamut of possibilities, from 'un-art' to 'super-kitsch', as Haftmann put it. He used montage, a technique learnt from Dadaism, and was not afraid to use the most kitsch objects in his work.

From about 1920 on, his disturbing themes included war invalids, whose terrible mutilations and horrifying artificial limbs are brought into the picture with such merciless precision that it becomes clear that the obsession with facts is designed to show that it is not personal sympathy for the man, but

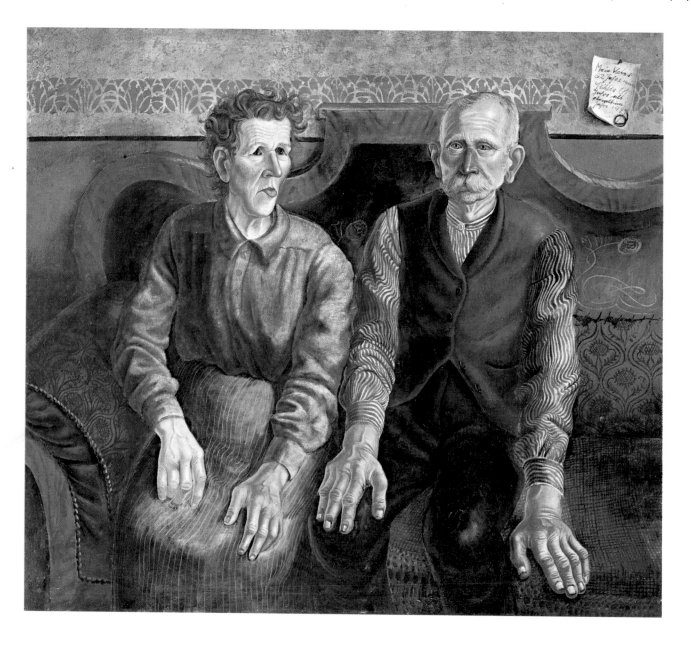

only the abolition of all war which will put an end to such mutilation.

In *My Parents*, the figures are depicted with scrupulous accuracy, with every detail of the pattern on the wallpaper and every line on the foreheads carefully reproduced. The minutely examined 'superficiality' becomes the only means of showing the unchangeability of the situation, the inexorable process of growing old and the way that they are tied to a specific social context—here represented by the sofa and the clothes. The depiction of the hands, abnormally large, and their place in the picture, play an important role both here and in the *Portrait of the writer Sylvia von Harden*. The characteristic features of the figures have, as it were, been concentrated in their hands.

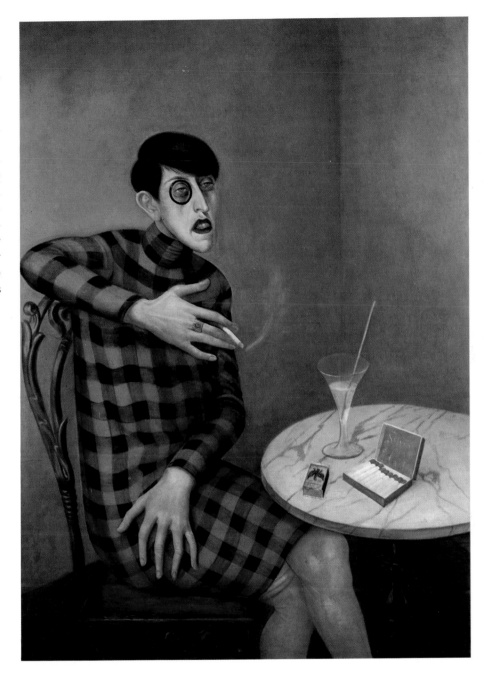

75 Otto Dix
Portrait of the writer Sylvia von Harden, **1926**
Mixed technique on wood, 120 × 88 cm
Paris, Musée National d'Art Moderne

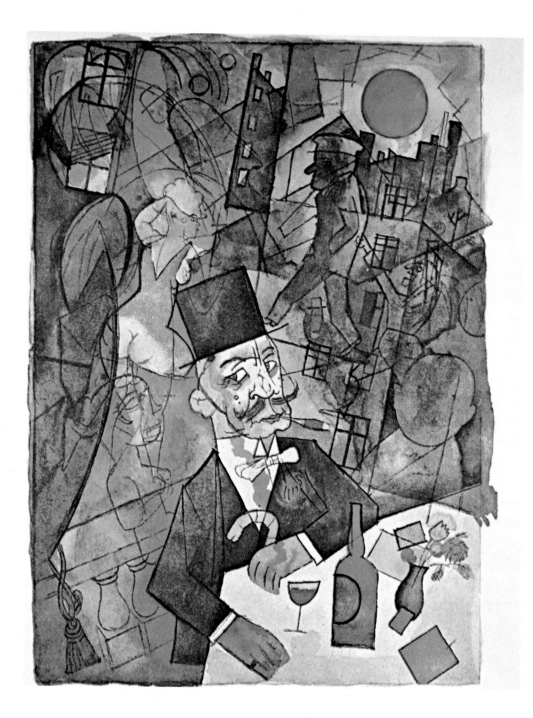

For George **Grosz**, art was essentially designed as a means of communication, of making a specific statement about something. What he saw in the world around him was abominations of injustice and hyprocrisy in social situations and conditions. His art is a pillorying art, as he himself wrote: 'Expressionist anarchism must cease. Nowadays, painters are forced to indulge in it, because they have no relation to the working man. But the time will come when the artist is no longer just a bohemian, a woolly anarchist, but a clear, healthy worker in a collectivist society' (Grosz, p.78).

'Through the very depiction of ugly things, which are in this work, and of which it might be assumed that they alienate a certain number of people, people are in my opinion educated. For if I depict an old man with the ugliness of old age and the ugliness of the uncontrollable body, then I achieve the result that, from early youth on, one looks after one's body, trains it, through sport, and so on. These are all quite specific moral tendencies, even in the portrayal of the grossest and ugliest things' (Grosz, p.86).

Grosz's main tool was really the pen, the sharp outline which is the most expressive point of his art. In his composition, he chose an eclectic approach, based on Expressionism, Cubism and Futurism, to the extent to which any of them could be useful to him: 'I now drew the outline of a figure, well-proportioned, and then arbitrarily, though skilfully, washed the whole drawing over in ink . . . I also began to use the thin, sharp drawing pen. But not freely, in the Rembrandt style—first of all I drew everything accurately in pencil, in order not to deviate a finger's breadth from the correct outline . . . My ambitious youthful plans of giant oil painting, easels the size of ladders and paintbrushes the size of brooms had faded into the background' (Grosz, p.22).

76 George Grosz
'Der Mädchenhändler' ('The White Slave Trader'), 1919, from *Ecce Homo*
Watercolour and ink, 42 × 30.2 cm
Berlin, Galerie Nierendorf

In 1932 Grosz took on a professorship in the U.S.A. He became resigned, and his art lost its drastic aggression; he no longer wanted to attack reality, but only to reproduce it. Even the most biting political art could do nothing against the rise of Fascism.

77 George Grosz
'Schönheit, dich will ich preisen' ('Beauty, I shall praise thee'), 1919, from *Ecce Homo*
Watercolour and ink, 42 × 30.2 cm
Berlin, Private Collection

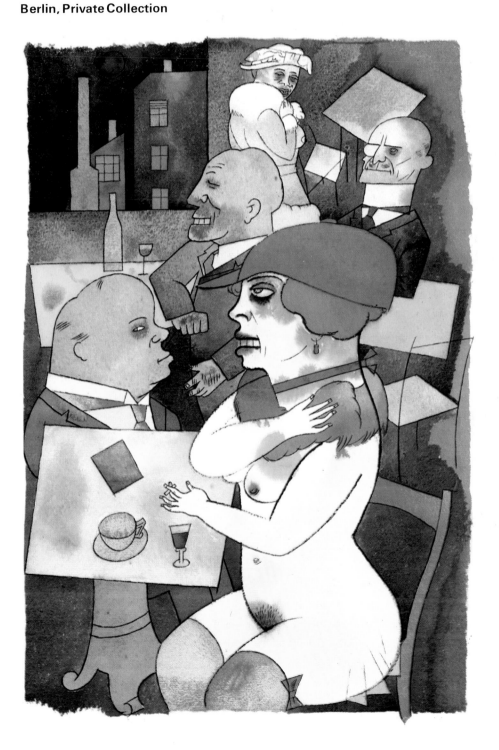

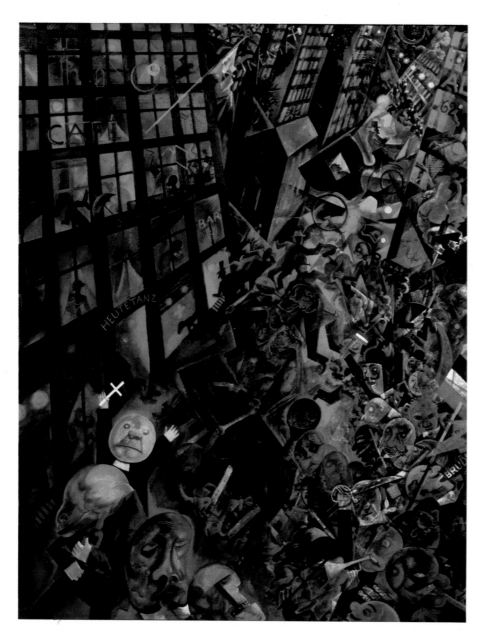

78 George Grosz
Homage to Oskar Panizza (Funeral),
1917–18
Oil on canvas, 140 × 110 cm
Stuttgart, Staatsgalerie